GARDENS OF POMPEII

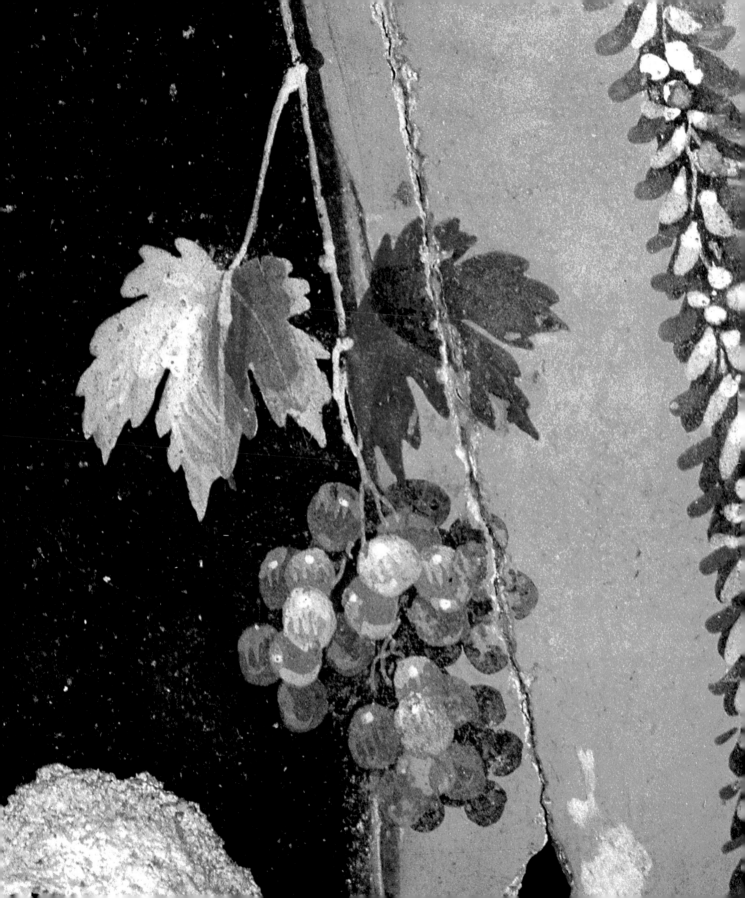

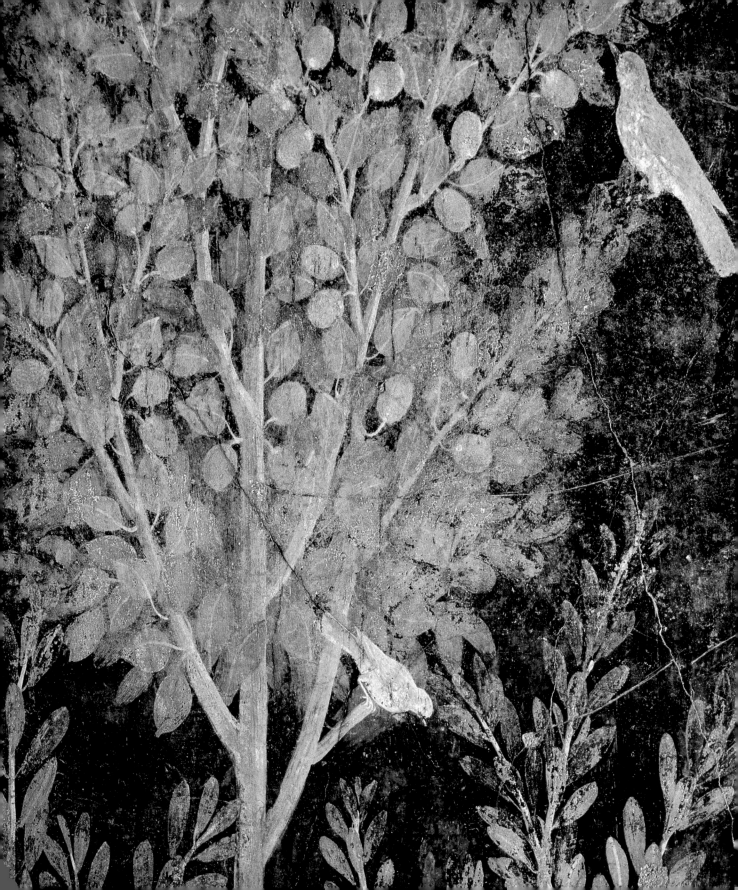

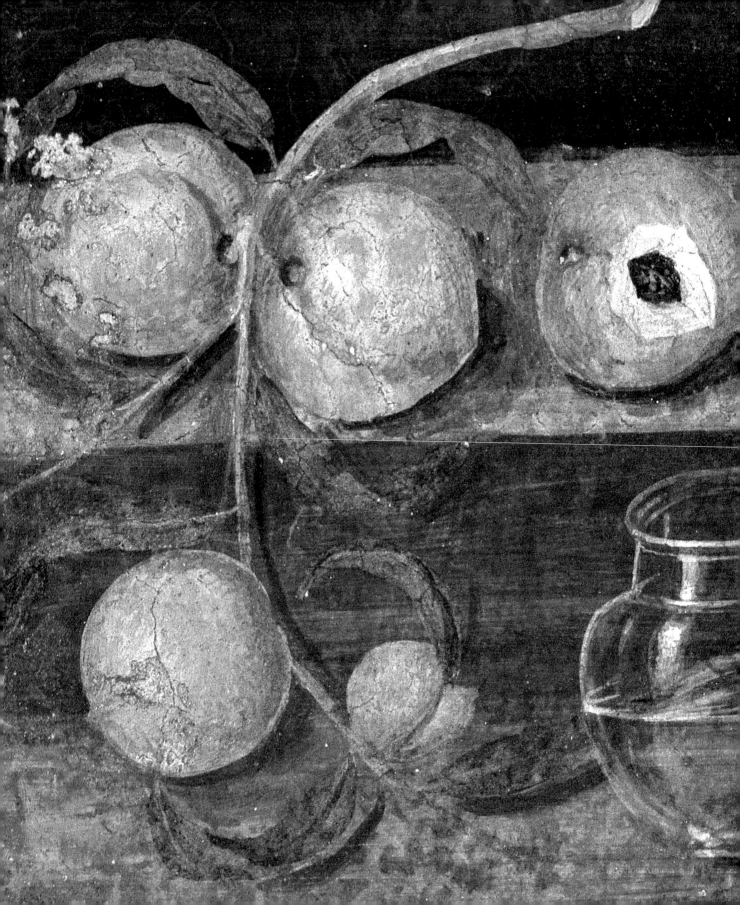

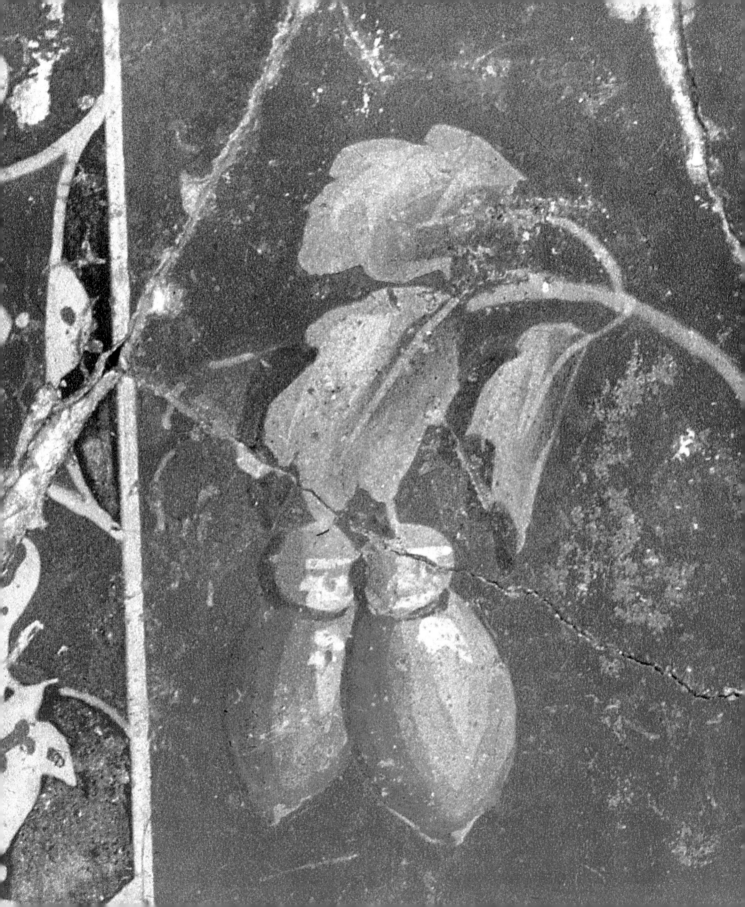

Annamaria Ciarallo

GARDENS OF POMPEII

The J. Paul Getty Museum • Los Angeles

Annamaria Ciarallo

Gardens of Pompeii

Translated by Lori-Ann Touchette

© 2001 «L'ERMA» di BRETSCHNEIDER
Via Cassiodoro, 19-00193 Roma - Italia

First published in the United States of America in 2001 by
The J. Paul Getty Museum
1200 Getty Center Drive, Suite 1000
Los Angeles, California 90049-1687
www.getty.edu/bookstore

At the J. Paul Getty Museum:

Christopher Hudson, *Publisher*
Mark Greenberg, *Managing Editor*

Library of Congress Catalog Card Number: 00-109711

ISBN: 0-89236-629-X

Printed in Italy

On the cover:

Pompeii. Fresco
Naples, Museo Archeologico Nazionale, unnumbered

Photographs:

Alfredo and Pio Foglia, Naples, and the Soprintendenza Archeologica di Pompei
The naturalistic photographs are by A. Ciarallo.

Aknowledgments:

I would like to thank L. Capaldo for providing access to his landscape photographs,
and my colleagues in the Soprintendenza Archeologica di Pompei for their constant collaboration.

CONTENTS

Thinking of Ada,
of the travels she dreamed of,
of her flower-filled balcony.

INTRODUCTION

A botanist's approach to dealing with antique flora is obviously very different from that of an art historian, archaeologist, or architect. An ancient representation of a plant reflects an observation of nature; a botanist's knowledge of the facts of nature makes it possible to understand whether a literary description or visual image is realistic or fantastic.

All this is not of slight importance, if one keeps in mind that in antiquity man's connection with nature, in particular with the plant world, was stronger and less mediated than it is today. We have become accustomed to seeing vegetables on a supermarket counter or to absent-mindedly driving past roadside greenery. But in the Roman period, and for many centuries afterward, people depended on nature in a way that was immediate and total. Plants were used for a myriad of purposes: for food, textiles, cosmetics, construction—even for military and religious ends. Above all, plants met curative needs, with one part or another of many plants used as medicines.

Becoming familiar with the plants encountered by ancient Pompeians, with their provenance and their utilization, therefore involves acquiring information concerning the social and economic life of the Vesuvian area.

In general, plants are repeatedly referred to in Latin literature, whether scientific, poetic, or popular. Nevertheless, they are difficult to identify, because it was not until the eighteenth century that objective rules of classification were introduced by Linnaeus. Typically, plants that were more common are described more clearly and can thus be more readily identified. This is true above all for the food plants, even though it is certainly not easy to disentangle oneself from the infinite number of varieties of wheat, grapes, and certain fruit-bearing trees cited, for example, by Pliny the Elder in his comprehensive *Natural History* (hereafter abbreviated as Pliny, *N.H.*).

Little by little, as one strays from the most familiar species, identification becomes almost impossible, thanks to continual comparisons to different characteristics of one species and another. It helps to see a plant depicted in the natural environment or to compare it with present-day flora. Doing so, without having recourse to specific references, one can draft a list of the species that grew in the region around Mount Vesuvius.

Varro, for example, cites the use of cypresses in the Vesuvian area to delimit properties. Columella mentions the cultivation of cabbage (Col., *Rust.* 10.135), the Pompeian onion (12.10.1), and the *Amminea gemina* variety of grape (3.2.10) and *Murgentina* called "Pompeiana" (3.2.27).

In light of the difficulties encountered in recognizing both plant and animal species described in literary sources, the naturalistic frescoes adorning Pompeian houses buried in the eruption of Vesuvius in A.D. 79 hold great importance for science. In addition, finds of ancient macro- and micro-remains that have been identified in the laboratory serve to complete and further amplify the information that iconography provides. Together, art and science furnish documentation unique for its breadth within a precisely dated historical moment.

Nowadays, it can be said that new species are acquired almost daily that increase the list of Vesuvian flora of A.D. 79 (see the plant list at the end of this book). The information that results is of particular interest for the history of botany. One can verify the period of importation of certain species that then became common in Italy. Consider, for example, the peach, apricot, cherry, and, surprisingly, lemon and pineapple. The lemon was believed to be imported from the Arab world in the twelfth century; the pineapple to have come from the New World around 1500. But one was certainly already cultivated in the Vesuvian area, the fruit of the other almost certainly imported from India or Africa, to confirm a hypothesis already proposed in 1800 by De Candolle. All of this testifies to an extremely active exchange of species between geographically distant regions. That exchange is paralleled only fifteen centuries later, when the exploration of the New World helped fill the Italian countryside with peppers, potatoes, tomatoes, tobacco, agaves, and prickly pears, while oranges, plums, and grapes ended up in California.

Just as fascinating, however, are the present-day flora flourishing in the Vesuvian archaeological zone, which has been owned by the state for 250 years. In this area, in fact, indigenous species that had been driven out of the surrounding area by the indiscriminate urbanization of the last forty years and the heavy use of pesticides in agriculture have found refuge. A list of species currently present in the archaeological area of Pompeii appears at the end of this book.

INDIGENOUS AND INTRODUCED SPECIES

As stated in the introduction, it is not only the study of vegetal micro- and macro-remains that reveal which species were the most widespread in the Vesuvian territory. Frescos very frequently depicted plant subjects, sometimes in so accurate a manner as to permit, in the case of cultivated plants, the identification of the variety.

Usually, native species were represented in paintings that recreated garden scenes. Among the most common were *compositae* (now commonly called field daisies), periwinkle (fig. 1), ivy, ferns, Solomon's Seal (fig. 2), violets, and opium poppy (fig. 3). This last was a well-known medicinal plant. Shrubby and arboreal species typical of the Mediterranean habitat, such as arbutus berry, laurel, and viburnum (figs. 4–6), also appear in ancient frescoes.

Species from different habitats were sometimes combined in the paintings. Generally, this occurred when a representation conveyed symbolic significance associated with a particular species.

Even more than for information about the indigenous flora of the Vesuvian area, iconography is important for helping us learn which exotic species were known and which were actually cultivated. In some cases, palynologic analyses (examination of ancient pollen and spores) have confirmed information gathered from iconographic references.

Exotic plants were often depicted in genre pieces such as the so-called Nilotic scenes: lotus flower and date palm came to compose landscapes in which ibises, hippopotami, and crocodiles appeared (figs. 7–9).

1

2

1. Periwinkle (*Vinca* sp.)
Fresco (detail). Pompeii, House of the Wedding of Alexander. Considered a garden plant, periwinkle was nevertheless included in the composition of garlands when there was a shortage of other flowers. It also had numerous uses in medicines. For example, it cured dropsy (Pliny, *N.H.*, 21.98.172 and 39.68).

2. Solomon's Seal (*Polygonatum multiflorum* [L.] All.)
Fresco (detail). Pompeii, House of the Wedding of Alexander. Symbolically, it indicated fecundity, but it was also used to treat toothache, lumbago, and fractures (Pliny, *N.H.*, 12.18.40).

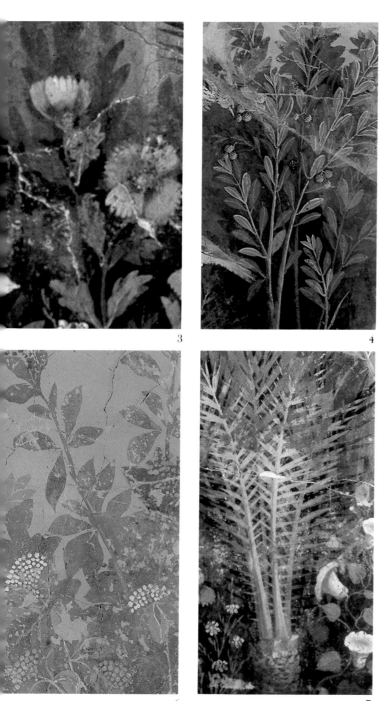
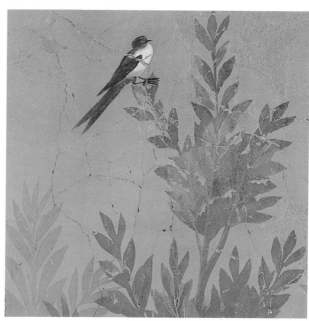

3 4

5

6 7

fruit was also known. The latex was always considered dangerous for vision, and even today children are cautioned not to touch their eyes with their hands after collecting the flowers.

4. Arbutus berry (*Arbutus unedo* L.)
Fresco (detail). Pompeii, House of the Wedding of Alexander.
The plant is depicted here in an extremely accurate manner, so that it is possible to recognize the fruit in different stages of maturation. The edible fruits appear on the plant together with the flowers, a characteristic of the plant.

5. Laurel (*Laurus nobilis* L.)
Fresco (detail). Pompeii, House of the Wedding of Alexander.
The plant, dedicated to triumphs, was also used in medicine and in cooking. Pliny records its use in the preparation of "mostaccioli" (*N.H.*, 15.39.127).

6. Viburnum (*Viburnum tinus* L.)
Fresco (detail). Pompeii, House of the Wedding of Alexander.
This beautiful Mediterranean shrub flowers in late winter with umbels of white flowers. The buds' rosy color contrasts pleasantly with the metallic blue of the fruit.

7. Date palm (*Phoenix dactylifera* L.)
Fresco (detail). Pompeii, House of the Wedding of Alexander.
The depiction of the palm is rather frequent. Sometimes it was set into the so-called Nilotic scenes, other times it was proposed as a symbol of triumph and victory. The latter significance is still familiar to us today, if one thinks, for example, of the biblical significance of "Palm Sunday." The carbonized fruit of this species, the dates themselves, have also been found very frequently. These were then, as today, imported, since they are incapable of maturing in the local climate.

3. Opium poppy (*Papaver somniferum* L.)
Fresco (detail). Pompeii, House of the Wedding of Alexander.
The seeds of the opium poppy could cure insomnia, according to a use that continued in folk medicine up until half a century ago. The strongly narcotic effect of the opium obtained from the latex of the

Sometimes the species previously imported for cultivation, which therefore were already acclimatized, were represented alone, to emphasize their preciousness; other times they were combined with native species to produce compositions of symbolic significance. This tradition persisted for a long time and can be found in still lifes from the seventeenth century. Therefore, it is not easy to identify precisely when a new species was introduced. Nevertheless, useful information can be gleaned by comparing the ethno-botanical, bibliographical, and iconographical data and by recovering and examining micro- or macro-remains.

To provide one example, the date palm is repeatedly depicted in Nilotic scenes. Together with autochthonous species, it also appears in the frescoes of the House of the Wedding of Alexander, due to its symbolic meaning associated with triumphs. In the houses of ancient

9

8. Nilotic scene
Mosaic. Naples, Museo Archeologico Nazionale.
The nelumbius is easily recognizable in this mosaic with a Nilotic scene. The characteristic cup-shaped fruits, which contain seeds known as Egyptian beans, are strikingly reproduced here.

9. Nelumbius (*Nelumbo nucifera* Gaertner)
Mosaic (detail). Naples, Museo Archeologico Nazionale.

MEDICINAL PLANTS

*A*lthough it might seem strange, both animals and plants were used in ancient medicine. All parts of the latter were used. Modern pharmacology has in some cases confirmed the efficacy of the active ingredients contained in remedies; in other cases it has verified their ineffectiveness.

For example, the willow, which the ancients used in compresses to cure rheumatic pains, contains a high level of salicylic acid, from which common aspirin is made.

Digitalin, prescribed today for cardiac diseases, is taken from digitalis, used in antiquity for treating angina attacks. Extracts of poppy seeds to combat insomnia, compresses of lettuce to assuage toothache, and application of flaxseed to reduce bronchitis, to cite only a few, were remedies still employed until a few decades ago in Italy. Their application was justified by the active ingredients contained in them, combined, for example, with the effect of heat.

In other cases, magical or superstitious elements came into play. Pliny, for example, while critical of his ancestors' excessive credulity, nevertheless transmitted beliefs that became part of folklore passed down to the not-too-distant past.

In a majority of the cases, a large number of ingredients entered into the composition of a medication. Plants were set to steep in wine, whose alcoholic part became a base for the active ingredients. A complex preparation with many components, traditionally attributed to Mithradates, was transmitted for centuries under the name of teriaca; at the end of the nineteenth century, it was still prepared in the Monastery of Casamari.

The plants shown here are plants well known to us that were used for medicinal purposes in antiquity.

A-1. Oak (*Quercus pubescens* Willd.)
The leaves, bark, and acorns were utilized to reduce the inflammation of abscesses and festering wounds. The extract in fomentation reduced lethargy of the limbs, whereas the roots counteracted snake venom (Pliny, *N.H.*, 24.7).

A-2. Fig (*Ficus carica* L.)
The latex was considered useful to cure warts. The leaves and unripe fruit had emollient properties. Sore throat was treated with dried figs. Ashes dissolved in water and oil were used against tetanus, convulsions, and fractures (Pliny, *N.H.*).

A-3. Quince (*Cydonia oblonga* L.)
Compresses of cooked quince made hair grow back and cured stomachache. Raw quince juice was beneficial for spleen ailments, dropsy, and varicose veins (Pliny, *N.H.*, 33.54).

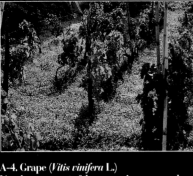

A-4. Grape (*Vitis vinifera* L.)
Nearly every part of the grapevine was used, not just for making wine, but also for the preparation of so-called medicated wines. Unripe grapes served to prepare verjuice, considered effective against infections of the mouth. Raisin wine entered into the composition of teriaca; grape seeds cured stomachache, just as vinegar did (Pliny, *N.H.*).

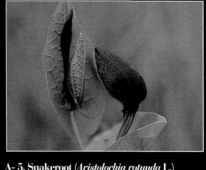

A-5. Snakeroot (*Aristolochia rotunda* L.)
Useful against liver disorders, snakeroot also cured jaundice and diseases of the stomach and uterus. Combined with wine, it was an effective diuretic (Pliny, *N.H.*, 21.78).

A-6. Feverfew (*Matricaria parthenium* L.)
This plant was used to treat menstrual complaints and uterine pains. It was also used to cure colic and hysteria and to halt milk production in women.

A-7. Poppy (*Papaver rhoeas* L.)
Poppy seeds crushed in milk were taken as a sleep aid. The same seeds, chopped and mixed in rose oil, cured headache and earache. In compresses with vinegar, poppy seeds were used to heal wounds and to recover from poetic inspiration (Pliny, *N.H.*, 20.76).

A-8. Catkins of the willow (*Salix caprea* L.)

A-9. Laburnum (*Laburnum anagyroides* L.)
The seeds of this plant are poisonous. In antiquity, Mithradates used them in a potion he devised that was composed of poisons and antidotes, mixed together to accustom the body to survive poisonings.

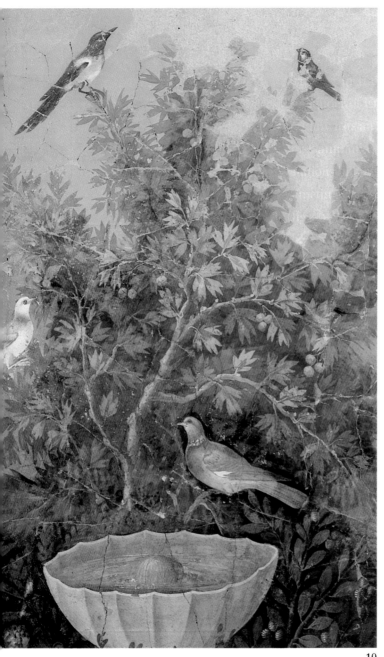

Pompeii, numerous carbonized dates have been found. Although the date palm was extremely well-known and cultivated in the Vesuvian plain, it was grown for ornamental purposes only, as the climate was ill adapted to bearing the fruit to maturity.

The nelumbius, or lotus flower, is another plant frequently represented in Nilotic scenes. Like the date palm, it was probably introduced to Italy as a garden plant. Its seeds, known as "beans of Egypt," had important medicinal value as well.

The plane tree was introduced from Greece (Pliny, *N.H.*, 12.3.6), also for decorative purposes (fig. 10). Repeatedly represented for its symbolic significance linked to overcoming life's difficulties, it was cultivated to such an extent that it appears in the fresco recording the clash in A.D. 59 between the Nucerians and the Pompeians. In addition, its root cavities, of which casts have been taken, have been found in the region of Pompeii that early excavators designated *Regio* II, and the impression of plane leaves remain in the volcanic material deposited at Stabiae.

A case of more dubious interpretation is that of the oleander (figs. 11-12). This species is widespread along washes and dry riverbeds in the south of Italy. We do not now have data to verify whether it also existed in the Vesuvian area in antiquity. That it was perhaps cultivated is demonstrated by the fact that its pollen and the impression of its leaves have been found in the ashes.

10

10. Plane tree (*Platanus orientalis* L.)
Fresco (detail). Pompeii, House of the Wedding of Alexander.
Regarding the oriental plane tree's introduction into Italy we have the information transmitted by Pliny the Elder himself, who in the *Natural History* recounts how it had been introduced into the Tremiti Islands by the Greeks. The plane tree then passed onto peninsular Italy, where it was carried by Dionysius the Elder, tyrant of Syracuse, to decorate the palaestra of his residence in Rhegium. Using the trees in this way became established in the Roman world, as the casts of the roots found at Pompeii demonstrate. The plane tree was then transported to Sicily. Moving north through Italy, it reached the northeast border of Gaul (modern-day France) during the time Pliny wrote.

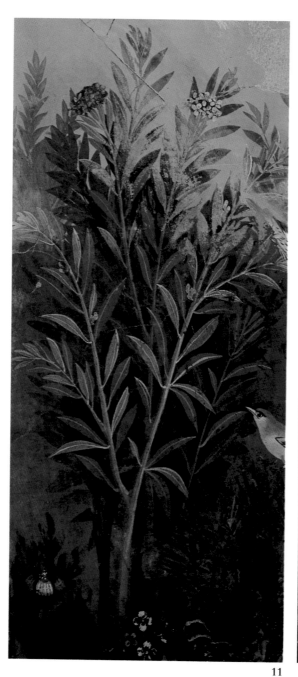

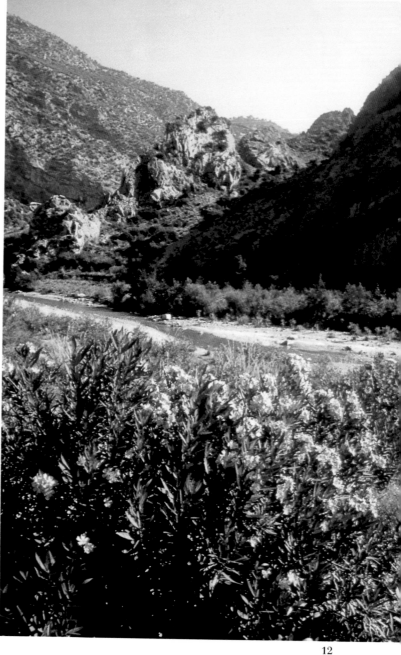

11

12

11. Oleander (*Nerium oleander* L.)
Fresco (detail). Pompeii, House of the Wedding of Alexander.

12. Oleanders in the riverbed of the Raganello in Calabria
The oleander is perhaps one of the most frequently depicted plants in Pompeian frescoes. In their natural state, oleanders still brighten the arid Calabrian in the summer, flooding them with their color, which stands out on the white rocks of the completely dry riverbed. Whoever has enjoyed this spectacle of extraordinary beauty finds it difficult to rediscover its fascination in cultivated exemplars. This happens to a certain extent for all species whose splendor in their natural context seems impossible to duplicate when cultivated.

The frescoes do not provide information only about species native to or introduced to the Vesuvian region. They also provide evidence about hybridized varieties that were bred for their beauty, or, in the case of edible plants, for their productivity or tastiness.

Among the ornamental plants bred for their decorative appeal, variegated ivy (fig. 13) and roses should be mentioned. In ancient representations, roses are depicted with more petals, which indicates cultivated forms, given that the spontaneous type has only five petals. In fact, the *versicolor* rose's period of selection, previously thought to have occurred in the 1100s, has been down-dated on the basis of Pompeian iconography (fig. 14).

13

The abundance of varieties was even more important for culinary plants than for ornamental species. In ancient times, the supply of edible species in a territory was restricted to what nature offered spontaneously. On the one hand, this limited the number of foods available; on the other, it imposed strict seasonal patterns of food availability. That is why famine was a real calamity, one that caused people to eat foods, such as acorn flour and mice, now generally regarded as unpalatable.

Nature's control of plant availability is also the reason that certain plants, for example the olive and the grape, were considered "sacred" (figs. 15–16). Felling a single specimen of these special plants warranted the death penalty in *Magna Graecia*, as prescribed in the Heraclea tablets found in Lucania.

13. Variegated ivy (*Hedera helix* L. var. *variegata*)
Fresco (detail). Pompeii, House of the Wedding of Alexander. The ivy in the House of the Wedding of Alexander is represented in its natural form and in the so-called variegated hybrid form. The great naturalistic accuracy with which the frescoes of the House of the Wedding of Alexander had been executed and the large number of species depicted have resulted in the advancement of the hypothesis that the proprietor cultivated plants for wreaths. These plants were included in the compositions of wreaths used for votive purposes, in which case the symbolic attribution of the species was important; or for wreaths for curative purposes, in which case, for example, the quality of the perfume emitted by certain species prevailed.

14. *Rosa gallica* L. var. *versicolor*
Fresco (detail). Pompeii, House of the Wedding of Alexander. The number of varieties of roses that from the Greek period onward were bred to produce more petals or an ever more intense perfume is truly enormous. In antiquity, for example, the roses of Campania were particularly prized for their perfume. Among the varieties derived originally from the gallica roses, which have only five petals in the wild, it has long been considered that *versicolor* had been bred in a much later period, that is, in the twelfth century, to commemorate the mistress of Henry II, Rosamund. Thus, the rose was given the name *Rosa mundi*. The frescoes of the House of the Wedding of Alexander demonstrate, however, that it was already known in A.D. 79.

The frescoes of Pompeii help us to define when certain species were introduced—and sometimes that information is surprising. For an extraordinary example, consider the lemon, which was probably imported to Campania for its medicinal properties. Until a few decades ago, it was thought to have been introduced by the Arabs, but it is unequivocally depicted in a fresco of the House of the Fruit Orchard. Its cultivation in A.D. 79 must have been, however, still very recent, because not enough fruit had been produced to allow the recovery of seeds in the ground (fig. 17). The importation of the apricot from Armenia must also have been very recent (Pliny, *N.H.*, 15.11.39) (fig. 18).

In contrast, the importation of

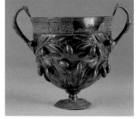

15 16

15. Vine (*Vitis vinifera* L.)
Fresco (detail). Pompeii, House of the Wedding of Alexander.

16. Olive (*Olea europea* L.)
Silver cup. Naples, Museo Archeologico Nazionale. The vine and the olive, together with grains, constituted the species that have been revealed as crucial for the birth and development of our civilization.

17. Lemon (*Citrus limon* L.)
Fresco. Pompeii, House of the Fruit Orchard. The lemon was imported from the Middle East. Pliny recounts that to encourage the seedlings to take root they were grown in perforated vases in their countries of origin to then be transported into Italy, where they were transplanted into the ground. The fruits were used for medicinal, especially antiseptic, purposes.

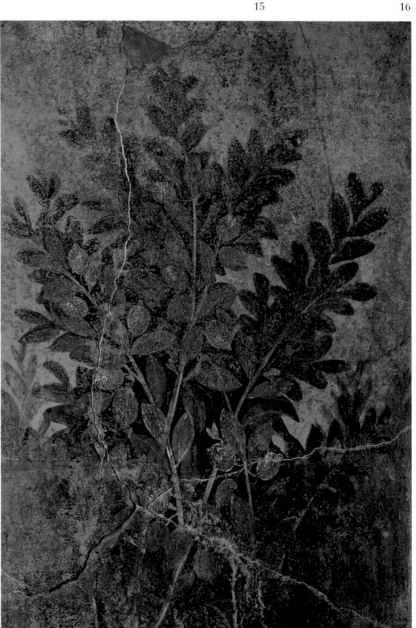

17

PLANTS FOR WREATHS AND GARLANDS

*A*mong the pictorial cycles of the House of the Vettii is that of the so-called Wreathed Cupids. The cupids are represented while they harvest and transport flowers with which they make up long garlands.

In daily life, wreaths and garlands had multiple functions. They were not only votive or commemorative, but also curative.

They were so important that Pliny devoted the twenty-first volume of his Natural History to flowers for wreaths and garlands. For commemorative and votive wreaths, the choice of flowers was made while keeping in mind the symbolic significance of the species; for curative ones, in contrast, the actual or presumed soothing properties prevailed.

This last practice, which might seem rather curious, finds a modern parallel in "aromatherapy," an approach more widespread among so-called alternative medicines.

B-3

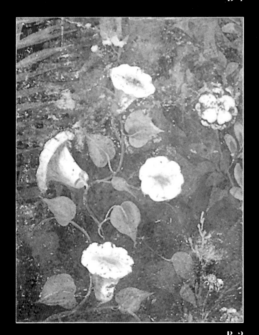

B-1

B-2

B-4

B-1. Chrysanthemum (*Chrysanthemum coronairum* L.)
Fresco (detail). Pompeii. House of the Wedding of Alexander.
The flowers "shine like gold when the rays of the sun strike them."
They were used to make garlands for dedication to the gods.
Chrysanthemum was also used in anti-inflammatory medicines.

B-2. Field bindweed (*Calystegia silvestris* L.)
Fresco (detail). Pompeii. House of the Wedding of Alexander.

B-3. *Calendula arvensis*

B-4. Cycle of the Wreathed Cupids
Pompeii. House of the Vettii. Among the pictorial cycles of the House of the Vettii there is that of the so-called Wreathed Cupids. They are represented while they harvest and transport flowers with which they then make up long garlands.

B-5

B-6

B-7

B-8

B-9

B-5. Dog rose (*Rosa arrensis* L.)

B-6. Love-in-a-mist (*Nigella damascena* L.)

B-7. Violet (*Viola arrensis* L.)

B-8. Stock (*Mattiola incana* L.)

B-9. Corn cockle (*Agrestemma githago* L.)

B-10. *Leucanthemum rulgare* (LAM)

B-10

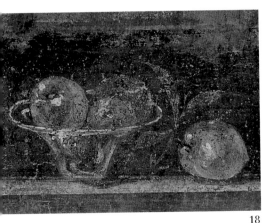

18

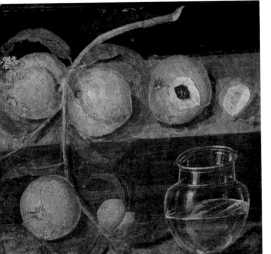

19

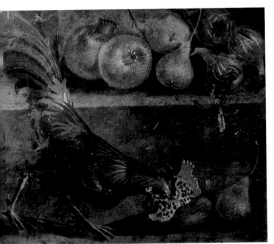

20

the peach from Persia (also for medicinal reasons) occurred much earlier. Its fruit is depicted in a fresco that comes from the House of Julia Felix, to which not by chance was annexed a vast fruit orchard. Peaches were certainly cultivated both in small urban vegetable gardens and in larger gardens of country villas. The repeated finds on grand scale of peach pits and peach wood attest to the fruit's diffusion (fig. 19). In particular, peach cultivation perhaps took on a special relevance in a *villa rustica* of Scafati, where medicinal potions were probably produced.

The pomegranate was also cultivated for principally medicinal purposes. This tree was definitely imported from Greece by the colonies that occupied Southern Italy. A symbol of eternity, like all fruit with a large number of seeds, it was sacred to Hera. At Paestum, but also in other colonies of *Magna Graecia*, votive reproductions in terra-cotta have also been found (figs. 20–21).

The cherry was imported by Lucius Lucullus in 74 B.C. from Pontus, then was exported toward Central Europe as far as Britain, which was conquered by the Romans in A.D. 43 (Pliny, *N.H.*, 15.30.102). Different varieties of cherry were known, but the Campanian one was particularly esteemed. It was identified as "clingstone" and was probably comparable to what the Italians call *durone* (fig. 22).

It is precisely the large number of varieties of certain fruit-bearing

18. Apricot (*Prunus armeniaca* L.)
Fresco. Naples, Museo Archeologico Nazionale. According to Pliny, the apricot, whose fruit is probably depicted here, was imported from Asia thirty years earlier (*N.H.*, 15.11.40). Its color and the rather oval form of its leaves, different from the peach's lance-like leaves, support this interpretation. Apricots in that period cost 1 denarius each because they were so exotic.

19. Peach (*Prunus persica* [L.] Batsch)
Fresco (detail). Naples, Museo Archeologico Nazionale. The peach was introduced from the Near East, primarily for its medicinal properties. Pliny writes of different varieties and especially of the great commercial value of the fruit (*N.H.*, 15.11.40), which cost 30 denarii each. The reason for such a high price is explained by the extreme perishability of the product. Considering the small size of the tree, the high commercial value of its fruit, and the necessity of a very rapid passage from producer to consumer, it's easy to understand how the peach tree's cultivation was well suited to small urban vegetable gardens.

20. Rooster and pomegranate (*Punica granatum* L.)
Fresco (detail). Naples, Museo Archeologico Nazionale.

species depicted in the frescoes that makes one aware of the tendency to ameliorate species, even those, like the fig, that were definitely autochthonous. For example, five varieties of fig are recognizable (figs. 23–24), eight of pears (figs. 25–26), three of apples (fig. 27), and two of plums (fig. 30).

Some of these varieties were widespread in the Italian countryside until a few decades ago, when they were superseded by modern ones that are more productive or are considered more striking, showy, or attractive. Their loss, like that of all those species that daily disappear from the world, constitutes an extremely serious injury to biological evolution and justifies attempts to preserve biodiversity in the world today (figs. 28–29).

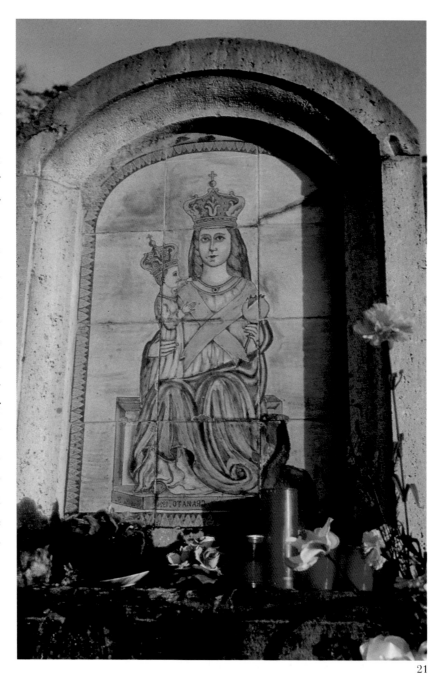

21

21. Madonna of the Pomegranate
Capaccio Vecchia, Salerno. Depicted frequently in the Pompeian frescoes, the pomegranate was already cultivated in the colonies of *Magna Graecia*. An extraordinary continuity has resulted in the fact that, dedicated to Hera in ancient Paestum, it remained later tied to the cult of the Madonna of the Pomegranate, at Capaccio Vecchia. This small town was founded in about the eleventh century in the environs of Paestum by refugees, descendants of the inhabitants of the Greek city that was abandoned because it became marshy.

22

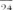

24

25

22. Cherry tree (*Prunus avium* L.)
Fresco. Pompeii. House of the Fruit Orchard. Pliny dates precisely when the cherry was introduced into Italy. He recounts that Lucius Lucullus brought it to Rome about 74 B.C.; he then follows its diffusion as far as Britannia. Different varieties were known, including a particularly prized Campanian one. (*N.H.*, 15.31.102 ff.)

23. Fig (*Ficus carica* L.)
Fresco (detail). Pompeii. House of the Fruit Orchard. Pliny enumerates twenty-nine different varieties of figs, including one prized in Herculaneum. He also writes that it had only recently been exported to Africa. (*N.H.*, 15.19.69 ff.)

24. Varieties of figs
Fresco. Naples, Museo Archeologico Nazionale.

25. Pear tree (*Pyrus communis* L.)
Fresco. Pompeii. House of the Fruit Orchard.

26. Varieties of pears
Fresco (detail). Naples. Museo Archeologico Nazionale. The pear, to judge from the large number of varieties represented, must certainly have been held in high regard. Pliny cites forty-one varieties. Of these, eight are easily recognizable in the frescoes and are comparable to an equal number of varieties still being cultivated in the Italian countryside in the 1950s. The varieties of fruit-bearing species usually took their name from that of the farmer who had created it through grafting or from the place of its production, more rarely from a specific characteristic such as form, color, or period of maturation.

27. Apple (*Malus domestica* Borkh.)
Fresco (detail). Naples. Museo Archeologico Nazionale. Apples were among the most widespread fruit-bearing trees. Over time, different varieties were bred, including "appiana," named for Appius, a member of the Clauda family who had done the grafting. Among the apples depicted, it is thought that one can also identify the so-called annurca apple, an esteemed Campanian type that is thought to have been cultivated around Pozzuoli.

28–29. Tables with different varieties of fruit
Naples, Biblioteca Nazionale. Manuscript Section. A comparison of the varieties of fruit trees cultivated in the Vesuvian area during the Roman period with the ones still widespread during the nineteenth century shows a continuity in the focus of breeding, all to the advantage of quality. This process has been interrupted today in favor of reduced selection that favors only quantitative aspects.

30. Plum (*Prunus domestica* L.)
Fresco. Pompeii, House of the Fruit Orchard. This splendid representation of a plum tree appears on one of the walls of the House of the Fruit Orchard. As with most plants, different parts of the plum tree were utilized. Diseases of the respiratory tract were treated with its leaves and the laxative effects of the fruit were recognized then, as they are today.

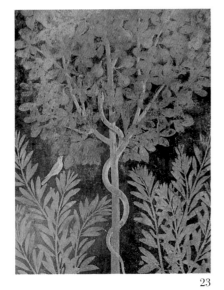

23

26

27

28

29

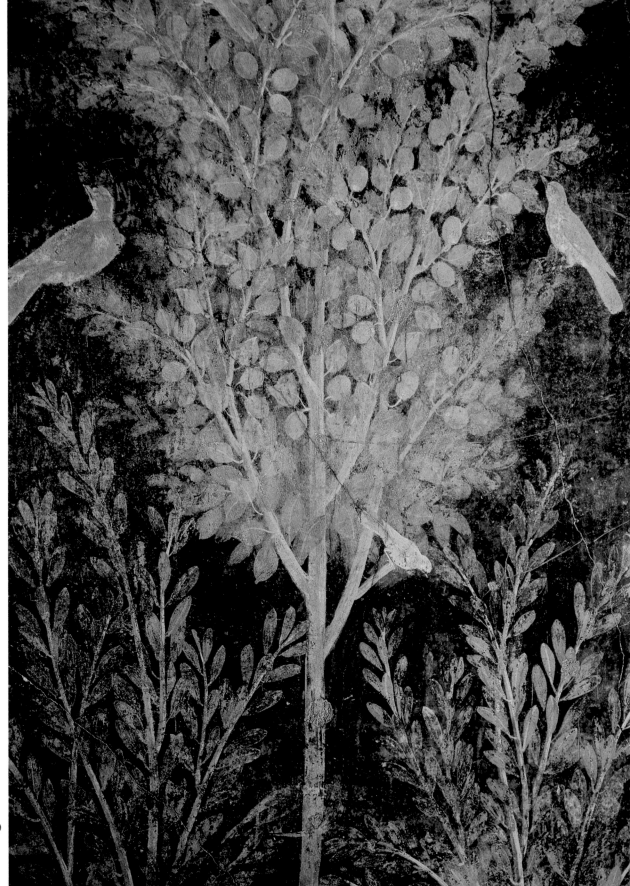

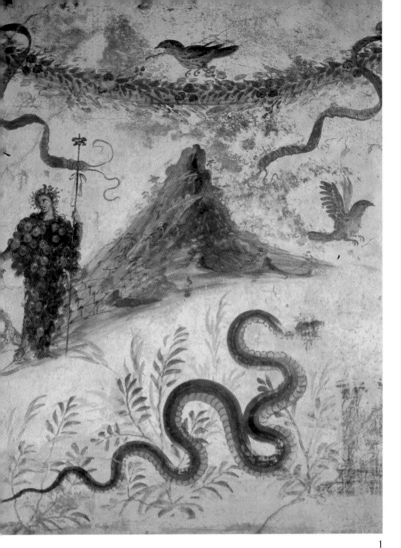

THE LANDSCAPE

It is not easy today to imagine the Vesuvian landscape of two centuries ago. Even before the effects of the devastating urbanization of the last fifty years, the eruption of A.D. 79 profoundly changed the appearance of the Vesuvian plain, rendering it unrecognizable to the inhabitants of the period.

The enormous pyroclastic emissions filled the valleys, deviated the course of the Sarno River, and advanced the coastline. In the explosion, the volcano itself lost the form of a single peak, as represented in the fresco of the *lararium* of the House of the Centenary, and acquired the two peaks familiar to us today (figs. 1–2). This last fresco gives us an idea of the ancient Vesuvian landscape; it was dominated by a single mountain whose volcanic nature was unknown, cultivated with grapevines on the slopes, and covered by forests on its summit.

The Sarno River lazily meandered across the plain, bordered by vegetation, before emptying into the sea along beaches bordered by dunes. Due to its broadly spiralling course, typical of "mature" rivers that have lost their torrential character, the Sarno was also called the Dragon (fig. 3).

1. Bacchus and Vesuvius
Fresco. Naples, Museo Archeologico Nazionale. This fresco was in the *lararium* of the House of the Centenary, so called because it was excavated on the occasion of the celebrations to commemorate the 1,800 years since the eruption of A.D. 79. The mountain that is depicted here, cultivated with grapevines on its slopes and thick with forests on the summit, is considered the most ancient representation of Vesuvius. Today, the mountain has two peaks, thanks to its eruption in A.D. 79.

2. Vesuvius as it is today
The eruption of A.D. 79 caused the destruction of the top parts of the volcano and the formation of a caldera, on whose foundation the actual cone has formed.

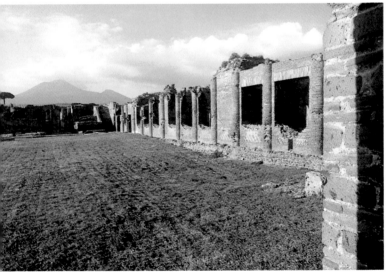

2

Comparative analyses of iconographic imagery, written descriptions, and the finds themselves makes it possible to reconstruct the salient elements of Vesuvian landscape of A.D. 79. In an imaginary voyage from the sea toward the peak of what was then considered Vesuvius, the vegetation changed to horizontal variations. Leaving the beaches scored by the branches of the delta of the Sarno, bordered by extensive beds of reeds, one walked in the shade of

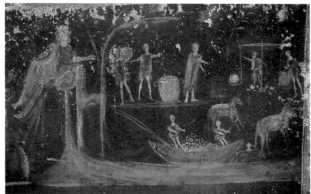

3

4

3. Sarno River
Fresco. Pompeii, House of the *Lararium* of the River Sarno. According to tradition, this votive fresco depicts the Sarno River, represented as an old man to symbolize the maturity of the river that beneficently bestowed its fresh waters. A ship goes up its course, lazily transporting, according to the tradition of some, onions, which were of great value in the Vesuvian area.

4. Environmental reconstruction of the area of the dunes behind the mouth of the Sarno
Boscoreale, Antiquarium Nazionale. A series of environmental reconstructions of the most common habitats that characterized the Vesuvian area in A.D. 79 was made on the basis of archaeological and naturalistic data (see also figs. 6, 9, 11). In this tract, the vegetation was composed primarily of extensive beds of reeds towered over by massive pine trees. In contrast, the weeds and shrubby plants that bordered the dunes were well adapted to strong sunlight and high salinity characteristic of that habitat. A large number of sedentary and migratory birds made their nests among the plants.

the pine trees that lined the terrain behind the dunes (figs. 4–5).

The pines' importance to the economy and to local traditions is demonstrated by extremely numerous representations and frequent finds.

In the lowest and most humid parts, the plains primarily hosted the cultivation of textile plants. Along the banks of the river, then navigable, there was thick riverine vegetation, in which sedentary and migratory birds made their nests. The willows and tall poplars growing there inspired the local place-name of Pioppaino.

Cypress trees were planted along the canals in an attempt to protect the terrain from flooding (figs. 6–8). In this way, cypresses were a species useful for the ability to reclaim marshes.

In the immediate environs of the city, vast vegetable gardens furnished the market daily with fresh vegetables. In the absence of refrigeration systems,

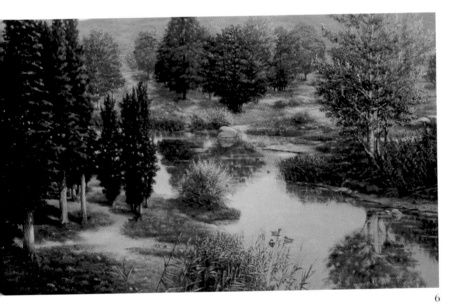

5

6

such gardens had to be located close to the city so that goods would not deteriorate in transit.

Little by little, as one moved away from the humidity of the lowlands, privileged cultivation, such as that

5. Pine tree (*Pinus pinea* L.)
Fresco (detail). Naples, Museo Archeologico Nazionale. Pinecones, like all fruits that produce numerous seeds, symbolized abundance and the renewal of life. In antiquity, they were set in small votive pits packed in the foundations of the house for the purposes of well-wishing. Today they are eaten between Christmas and New Year. In addition to the pinecones, the wood of the pine tree was used in shipbuilding. The resin extracted through the bark served to waterproof amphorae. The branches, bound together, formed so-called torches used for illumination. All parts of the plant had different medicinal uses.

6. Environmental reconstruction of a tract of the middle Sarno
Boscoreale, Antiquarium Nazionale. This reconstruction illustrates the vegetation involved in drainage attempts some years before Vesuvius's eruption in A.D. 79 along a tract of the course of the Sarno River. The trunks of cypress trees used for this work were found *in situ* a few years ago in an optimal state of preservation. The artificial grove demonstrates that the use of monoculture was widespread at the time. In this case, the slowly decaying cypresses promoted the formation in the semi-marshland of a mulch of roots, branches, leaves, and conidia that was useful as a vegetal filling material for raising the level of the land. The native vegetation was instead characterized by riparian species (such as poplars and willows) and, in the water, by fluvial species.

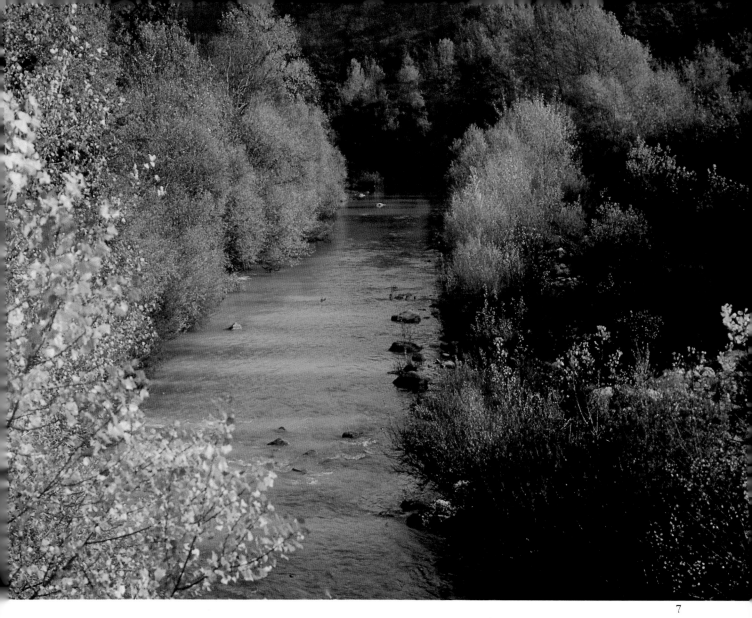

7. Riparian vegetation on the banks of the Ofanto River
An uncontaminated landscape makes it possible to imagine some of the habitats of the ancient Vesuvian territory.

8. Cypress (*Cupressus sempervirens* L.)
Fresco (detail). Naples, Museo Archeologico Nazionale. According to Pliny (*N.H.*, 16.60.141) the cypress was introduced to Tarantum from the island of Crete. The value of the cypress as a symbol of eternity was maintained intact from the Greek world. The fact that its wood is particularly long lasting, even in conditions of high humidity, probably strengthened this reading. Its properties were such that the Egyptians used cypress wood to make the chests to contain mummies. Varro recounted their widespread use in the Vesuvian area to delimit properties. Recently, the cavities left by the roots of some cypresses have been found in the funerary enclosure of a tomb of the necropolis of the Porta di Sarno, as testimony of an extraordinary continuity of symbolism that has been transmitted intact to our own day.

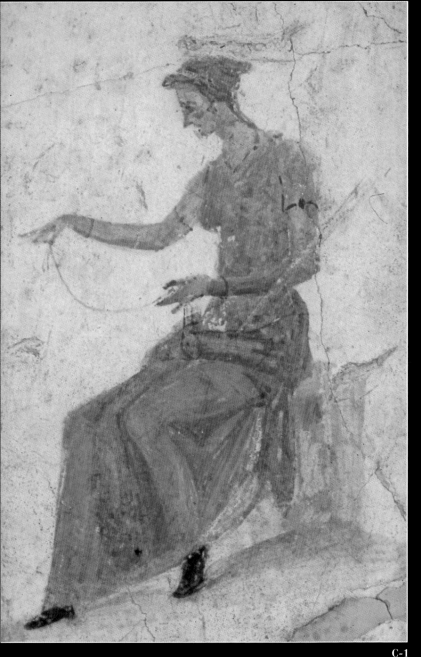

PLANTS FOR TEXTILES AND WEAVING

*T*extile fibers had great importance in the ancient world. They were used not only for clothing but also for tapestry and to make sails, fishnets, and ropes.

Textile fibers made from plant material were the most numerous type. Flax and hemp were cultivated in the Vesuvian plain along the canals formed by the Sarno River. Remains in the vegetative phase have also been found. It was necessary to stay in the vicinity of the river in order to prepare the basins in which the stalks were immersed. Once crushed, the stalks were then beaten to release the fiber. After repeated washes using ashes or soapwort roots, the fibers were softened and bleached, ready to be spun and

C-1

C-1. Picture of Fate with spindle
Fresco. Naples. Museo Archeologico Nazionale.

woven. The cultivation of flax and hemp in the area continued for centuries, until the sites were drained for hygienic reasons, beginning around 1500.

There are no traces of local cultivation of cotton in the Roman period; it probably was imported.

The use of broom, whose thread resembled that of flax, was also very widespread.

Other textile plants included native plants, such as esparto, used for the soles of lightweight shoes (the forerunners of Spanish espadrilles), and rush and sedge, for weaving mats.

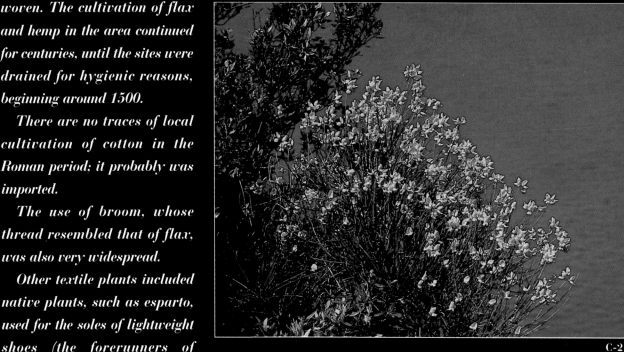

C-2

C-3

C-4

C-2. Broom in flower.
Broom fiber is still woven today in a few artisan workshops of Sila Greca.

C-3. Palm of St. Peter (*Chamaerops humilis* L.)
It is the only palm native to the region. At one time abundant, it was used to weave mats, wicker baskets, and shopping baskets.

C-4. Fuller's teasel (*Dipsacus fullonum* L.)
The dry flower head of the teasel was used to card wool.

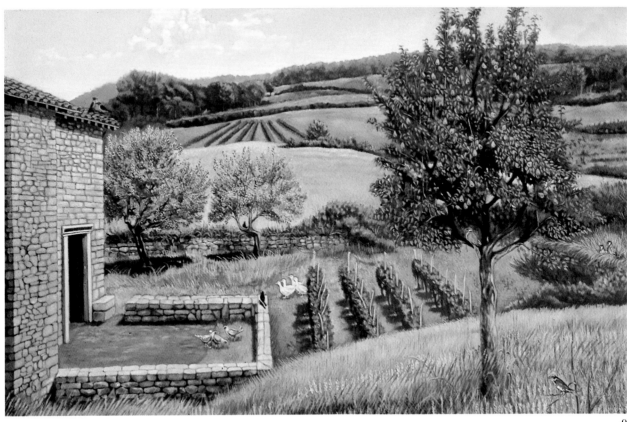

of viticulture and cereal growing, appeared on the sunny and ventilated slopes. Fruit trees sometimes punctuated the fields of wheat and barley. In contrast, the slopes of the Lattari Mountains, which closed the Vesuvian plain to the east, were planted mainly with olives. This last cultivation was adapted to the calcareous nature of that terrain. The fields alternated with pasture land, since crop rotation was in use. These were the sites in which the presence of *villa rusticae* was more

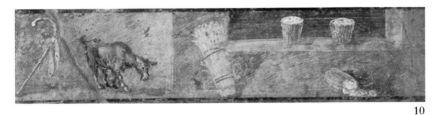

10

9. Environmental reconstruction of the Vesuvian hilly zone
Boscoreale, Antiquarium Nazionale. A corner of the so-called Villa Regina found in Boscoreale is reconstructed. Excavation data indicates that vines and fruit trees were grown near the building, and pollen analysis has revealed the presence of extensive fields of cereals in the immediate surroundings. *Villae rusticae* were more or less grand country houses, sometimes including richly decorated private apartments adjacent to vast agricultural estates. In these, there were servants' quarters, equipment for transforming produce (such as millstones, winepresses, and oil presses), and rooms for storing solid and liquid

foodstuffs. Agricultural estates usually included extensive forested areas that furnished material for daily use (especially wood) and provided a habitat where pigs could be raised in the wild and cross-bred with wild boars.

10. Pastoral scene
Fresco. Pompeii, House of the Vettii. One of the frescoes from the House of the Vettii portrays typical elements of agricultural/pastoral activities. Asparagus is depicted alongside a small donkey and some ricotta (stored in rush baskets, just as was still common in the Italian countryside up

11

widespread. These were true country houses with private apartments, servants' quarters, and equipment for the conservation and transformation of produce from the fields (figs. 9–10).

The tilled land toward the summit of the mountains abutted on mixed forests with a strong predominance of oak trees. Here, pigs were usually raised in a wild state to permit interbreeding with wild boars; thus meats particularly appreciated were obtained. The oak groves then gave way to beech groves, inhabited by deer and roe deer (figs. 11–12). A record of these great beech forests is the toponym Faito, one of the peaks of the calcareous complex of the Lattari Mountains. The white fir also enjoyed wide distribution; today relegated to the Appenines, at that time it constituted one of the materials most used in carpentry.

until a few decades ago). The thickness of the turion makes one think of a cultivated variety obtained through selection, since wild asparagus is much thinner. Moreover, Pliny and Columella treat at length the cultivation of asparagus, which, in addition to being considered an optimal food, was widely used in medicine. The turion, in fact, treated disturbances of the digestive system; the seeds and the roots, lumbago. Leprosy was also treated with the seeds and roots. For medicinal uses, however, the wild asparagus was considered more efficient, a principle still valid today in homeopathic medicine.

11. Environmental reconstruction of a mixed forest on Vesuvius
Boscoreale, Antiquarium Nazionale. In the high part of Vesuvius, one passed from a mixed forest of oaks and beech to pure beech groves that hosted deer and roe deer. These large mammals drew their own diet from "beech-nuts," the fruit produced by the beech trees. The deer's presence is demonstrated by the frequent finds of horns and the frequency with which they are depicted in graffiti, perhaps the work of children, found on the walls of Pompeii.

28
29

PLANTS FOR DYEING

*O*nce they had been prepared, the fabrics were colored using dyes derived from plant material. It is interesting to note how, depending on the fiber to be dyed and the mordant used (usually alum of potassium), different parts of the same plant could produce diverse colors. The coloring bath was prepared by boiling water and ammonia (urine was used as the source of ammonia), then adding the plant

D-1

D-2

D-1. Hollyhock (*Althea rosea* L.)
With the dried flowers, wool was dyed pink; with the leaves, it was dyed green.

D-2. Fullery of Stephanus
Pompeii in Via dell'Abbondanza. The installation of vats forms part of a larger workshop in which fabric was sized and dyed. To judge from the widespread recovery of loom weights, weaving was primarily a domestic activity. The looms used were of vertical type. Complex weaves of warp and weft, as demonstrated by the study conducted on fragments of carbonized cloth recovered, were also executed with these.

D-3

D-4

components that would yield desired color and the fabric to be dyed. For example, maple bark was used to dye wool brown; maple leaves to dye wool yellow. To obtain ancient pink, the root of the anchusa was used; for green, fresh chamomile flowers.

D-5

D-6

D-3. Gall
Galls are swellings that form on some plants as the result of the puncture that certain insects make to deposit their eggs. Oak galls are particularly rich in tannin and were used to dye wool and cotton a bronze color.

D-4. Safflower (*Carthamus lanatus* L.)
The flowers were used to dye wool red.

D-5. Berberry (*Berberis vulgaris* L.)
The bark was used to dye wool yellow.

D-6. Cupids as weavers.
Pompeii, House of the Vettii.

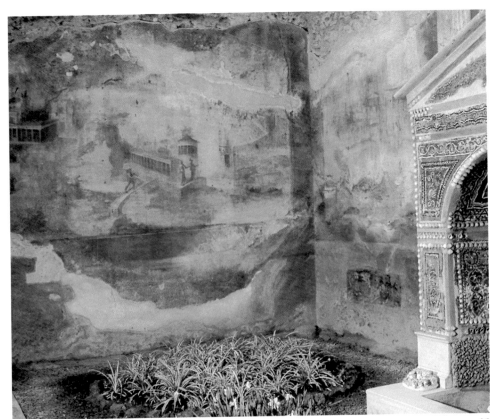

Such a description of the Vesuvian landscape of A.D. 79 does not serve only an aesthetic function but also provides insights about the region's economy. In fact, the area's components represented environmental resources that were integral parts of the economy of the sites. In antiquity, man was inextricably bound to the natural environment in which he moved, since he had to find the necessities of daily life in nature. That is why, from prehistoric times onward, human settlements developed where there was the availability of fresh water, spaces good for cultivation, and forests capable of furnishing wood and game.

Pompeii, with its fertile terrain, supply of clear water from the Sarno River, very extensive forests, mild climate, and proximity to the sea, was definitely a privileged site (fig. 13).

The very productions that rendered the city celebrated in the world, namely that of the fish sauce known as

12. Oak branch (*Quercus* sp.)
Fresco fragment. Pompeii, House of Fabius Rufus. Oaks, especially sessile oaks, were very diffuse in the forests that ascended the slopes to the summits of the mountains. Just as for the other woody substances, various parts of the oak were used in different ways. The wood was used in shipbuilding, the galls in tanning, because of their high tannin content. The acorns, usually used as food for pigs, were also ground into flour as an emergency food for humans in times of famine.

13. Landscape
Fresco. Pompeii, House of the Small Fountain. According to some, the large fresco that dominates the left wall of the *viridarium* in the House of the Small Fountain depicts the city of Pompeii, situated on the edge of a river where the waters flow into the sea.

garum and of good wine, came into being and expanded precisely due to the abundance of prime materials.

Garum required not only bluefish (anchovies, sardines, and mackerel), which were plentiful in the sea adjacent to the city, but also salt to prepare the brine (fig. 14). Salt, an extremely precious commodity of exchange, was produced in the salt marshes that developed in the lagunal sand banks extending between the city and the sea.

Vegetal pitch, drawn from the pines that were plentiful along the coast, served to waterproof the amphorae that held the wine. Similarly, wine could be produced on large scale not only because of

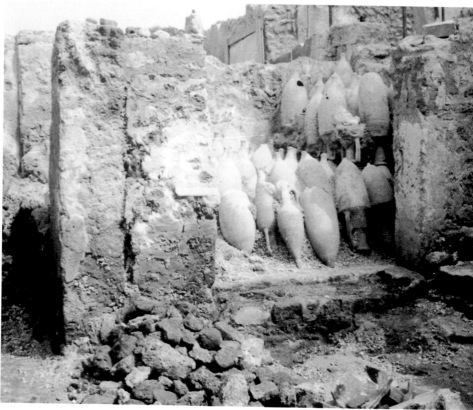

15

the vastness of the terrain planted with grapevines but also because the amphorae could be washed easily and repeatedly with seawater, or at any rate with salt water. This operation was considered indispensable for good conservation of the product (fig. 15).

The reeds that grew in great abundance in the delta and along the banks of the river had multiple uses. They were necessary in the countryside for supporting plants or delimiting flower beds, were utilized as weapons in the hunt, and, above all, were employed in construction (figs. 16–17). In fact, reeds were used to build the basic structure of walls and mezzanine levels: they were assembled into narrow bands and leaned on a wooden framework to which the plaster was applied. Their vestiges have remained well impressed into the plaster itself.

Because reeds grew and reproduced very rapidly, they made it possible to limit the use of wood, a material that

14. Bluefish (anchovies, sardines, and mackerel)
Fresco (detail). Naples, Museo Archeologico Nazionale. The large sardines shown, along with the other species that constituted the so-called bluefish, were part of the preparation of the fish sauce *garum*. It was made by collecting the liquid produced by the discarded parts of fish that had been immersed in brine.

15. Pompeii, *Regio* II
Sometime before the grape harvest, these amphorae, which must have been used to store wine, were washed in salt water and then set out upside down to dry. The large number of them found in this position in the excavations demonstrates that the grape harvest had not yet taken place when Vesuvius erupted.

was fundamental in daily life. Houses, transportation, tools, and many other useful items were constructed of wood, ships, simple machines, means of [transportation], whereas the less noble parts constituted the necessary fuel for cooking and heating. Wood was so important that extremely severe laws regulated the felling of trees. Extensive knowledge about the physical characteristics of different species allowed these to be bred and worked according to the use for which they were intended (fig. 18). The mechanical resistance of elm, for example, was exploited for making pivots and parts of carts. Furniture was constructed with fir, ships with oak and pine. Another striking component of the Vesuvian landscape, then as now, was broom. This also constituted a considerable resource in so far as it furnished prime material for basketry, provided strings for agriculture, and served as a valued textile fiber.

Very little trace of this antique Vesuvian landscape, beyond the profound alterations provoked by the eruption of A.D. 79, remains. The harmonious rapport that existed between man and the environment down to the second half of the nineteenth century deteriorated little by little until it was shattered definitively in the 1960s with the explosion of unauthorized building.

And yet, if one still wishes to grasp some fragmentary idea, it is enough to walk along the path little more than 3 kilometers (1.86 miles) long that, winding along the city wall to the north of the city, crosses a state-owned area

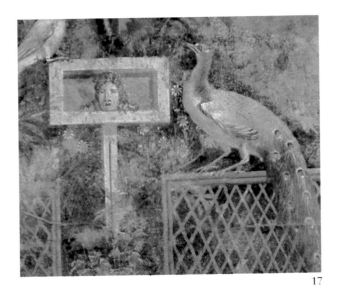

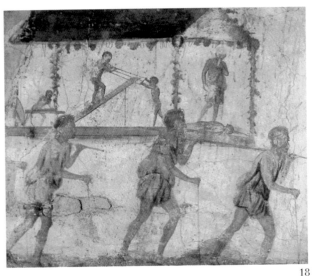

16. Rose with reed
Fresco (detail). Pompeii, House of the Wedding of Alexander.

17. Grillage
Fresco (detail). Naples, Museo Archeologico Nazionale. Two rather widespread examples of the use of the reed are depicted.

18. Carpenters carrying wood for the construction of a house
Fresco. Naples, Museo Archeologico Nazionale. Carpenters constituted one of the guilds of ancient Pompeii, as testified to by their role in the city's daily life.

19–20. Views of the *extramoenia* (area outside the city walls)
Along the first part of the path, the thickness of the pyroclastic blanket that buried the ancient city appears clearly. In fact, it constitutes the current surface of the countryside, whereas in A.D. 79 the surface was several meters lower. That is why one today looks down into a large part of the archaeological area.

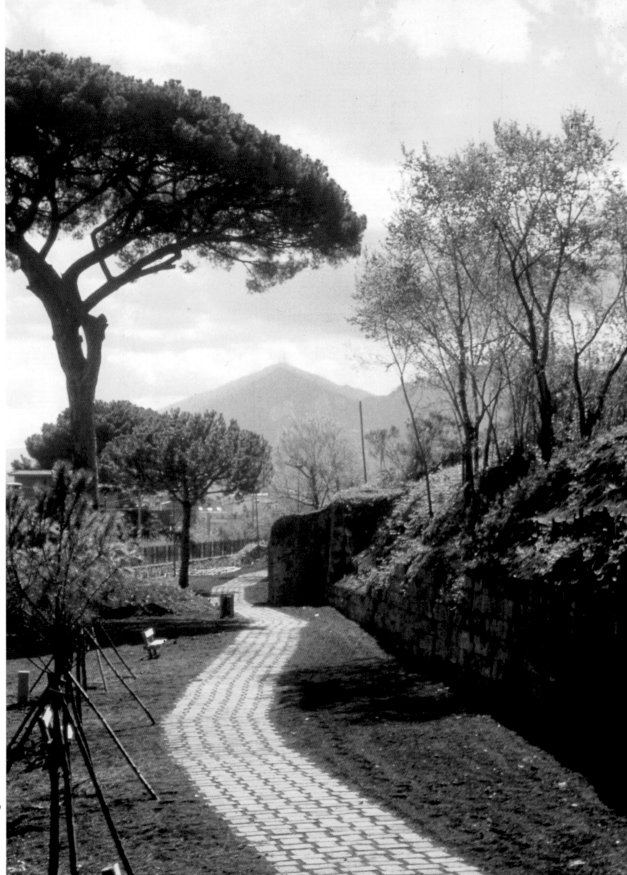

19

20

21

of about 20 hectares (50 acres). Here, one can understand man's relationship with the territory simply by surveying the surprising richness of native flora that, driven out of the environs by the effects of human habitation and the indiscriminate use of pesticides, has found refuge in the last 250 years in the state-owned lands of the archaeological area (figs. 19–21).

21. Landscape at the edge of the excavations
Watercolor by A. Pisa. The thick native vegetation that runs along the entire route is characterized by herbaceous, shrubby, and arboreal vegetation. This last includes some spectacular exemplars of umbrella pines and sessile oaks, all quite large when the excavations began.

URBAN VEGETATION

At one time, small cities, villages, and castles were relevant to the description of a landscape. They arose in harmony with the land and were therefore an integral part of it. A vast iconography from the Medieval period through to part of the nineteenth century offers landscape views that include buildings. Even as early as the first century B.C., Virgil, in book 2 of the *Georgics*, magisterially described the Italian landscape: "Olives and cheerful herds cover her [Italy]. Here there is continual spring and summertime in months that do not belong to them, twice the herd becomes pregnant, twice the tree bears fruit. Add many glorious things and works of art, many castles constructed on precipitous rocks and rivers flowing under ancient walls."

Today, we can comprehend this concept of landscape only when we distance ourselves from large urban centers. Where the city extends itself in a sprawling manner, such a view no longer exists in the entirety of its significance.

Pompeii certainly formed a part of the Vesuvian landscape of A.D. 79. The city rose on a spur of lava rock that overlooked an ample beach. The foliage of the tallest trees cultivated in the gardens and urban vegetable gardens rose above the rooftops, revealing the presence of large and small green spaces. Entering the city, one would become aware that plants were also cultivated on balconies and galleries. Sometimes they grew so thickly they give the impression of a "forest," as recounted by Pliny (*N.H.*, 15.14.47).

This was an urban landscape comparable to many representations of Pompeii that, while perhaps not reflecting with certainty a view of Pompeii, accurately describe a reality at any rate widespread (fig. 1).

The gardens closed within the tall walls of ancient Pompeii constitute an extraordinary

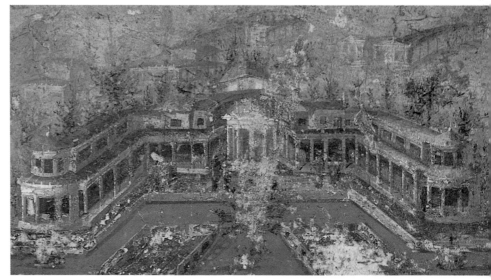

1

1. Urban landscape
Fresco. Pompeii, House of Loreius Tiburtinus. Many small paintings decorating the walls of Pompeian houses depicted architectural landscapes that give an idea of how the urban structure of the city must have appeared. The most lavish houses overlook the sea, with terraces systematized as ample lawns. On the ground, the trees' foliage towered over the houses, hinting at the presence of numerous green spaces.

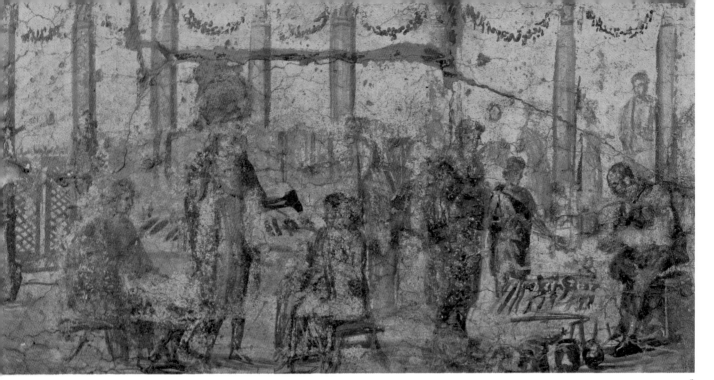

patrimony. On the one hand, they uniquely demonstrate the way vegetation was distributed within a city two thousand years ago. On the other, the criteria of their replanting over the course of 250 years of excavation activity have relevance for the history of the restoration of the Pompeian gardens over the centuries.

The city, enclosed within its walls, extends for 66 hectares (163 acres). Eleven gates and as many road axes placed Pompeii in communication with the surrounding territory. The then-navigable Sarno River permitted the city's inhabitants to enjoy commercial exchange with the interior, and the sea put them in communication with the entire Mediterranean basin.

The favorable climate and availability of rich environmental resources made it possible for the city's inhabitants at various levels of society to lead diverse and animated lives that included performing different arts and crafts (fig. 2).

About two-thirds of this city today is exposed; the northeast sector has not yet been unearthed. Excavations have revealed about 450 green areas of different dimensions distributed in a more or less heterogeneous manner. Larger spaces are concentrated in *Regiones* I and II, that is, in the southwest portion of the city. Excavation techniques, assisted by new methods of analysis, have restored these to their original use.

2. Scene of vines in the Forum
Fresco. Naples, Museo Archeologico Nazionale. A vivacious market scene in the Forum square. Pompeii, like all seaside cities, was the center of intensive commercial exchange with other coastal towns.

3. *Viridarium*
Pompeii, House of the Vettii. The stratigraphic excavation of the garden of the House of the Vettii in 1883 made it possible for the first time to reveal the network of paths and flower beds. In the reconstruction of the *viridarium*, the layout came down intact to our time, and the species planted out were chosen from those depicted in the frescoes of the peristyle. In particular, ivies in hemispherical forms, just like those depicted, were planted in the garden.

Evidently, these were the peripheral districts. At the moment of the eruption, they underwent an instantaneous "urban transformation." Like all peripheral districts, they had vast enclosed spaces once set aside for agricultural purposes or artisan activities.

We do not have reliable data on the cultivation that took place in the gardens of the earliest houses brought to light. This is due to the fact that the rise of stratigraphic excavation respectful of the traces left in the ground by the plant roots was not established until the second half of the nineteenth century.

In the larger *viridaria*, or interior gardens, the land was divided into flower beds that were slightly elevated above the beaten-earth paths. The flower beds were fenced by grillages of reeds, as revealed, for example, in the excavations of the garden of the House of the Vettii and, more recently, in the so-called House of the Chaste Lovers (figs. 3–4). Thus, what appears in the iconography is confirmed.

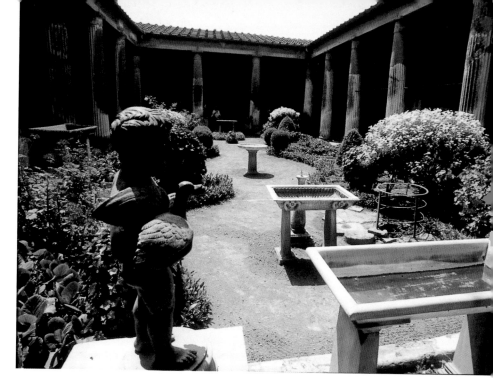

3

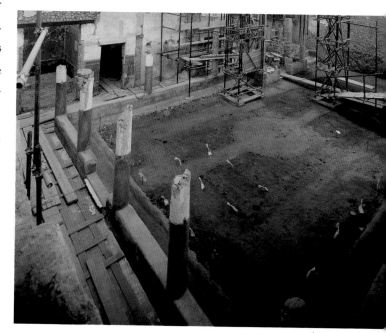

4

4. *Viridarium*
Pompeii, House of the Chaste Lovers. The garden of the House of the Chaste Lovers was chronologically the last excavated. This has made it possible to study it adopting the most advanced investigation methods. In particular, by systematically identifying pollen, woods, and seeds on the entire surface and then carefully studying the cavities present in the ground, it is possible to establish with almost absolute certainty not only the species actually cultivated but also those utilized in different ways. In fact, only when a species is identified contemporaneously through pollen, wood, and seeds and is compatible with the cavity left in the ground can one say that it was actually grown in that site. In the garden of the House of the Chaste Lovers, the plants that correspond to these requisites are juniper, roses, and artemesia (cf. *A. abrotanum*). The same is true of the *Cerastium* sp. and the *Lychnis coronaria* L, which occupied the flower beds in an almost symmetrical manner, as well as the vines that masked the foundation wall and the fern plants (*Polypodium*) that grew along the channels. Two aspects of the excavations of the garden of the House of the Chaste Lovers, however, seem to be most interesting. On the one hand, the excavations have revealed how the flower beds were designed to correct asymmetries and accentuate the profundity of the field with respect to the most significant rooms that flank the garden. On the other hand, they also confirmed the use of grillages, just as depicted in the garden paintings, to fence the flower beds themselves. In fact, along the borders of the flower beds a myriad of small holes that accommodated thin reeds by way of fencing, at fixed intervals tied to larger reeds as a means of support, have been revealed.

THE RICHNESS OF THE POMPEIAN GARDEN

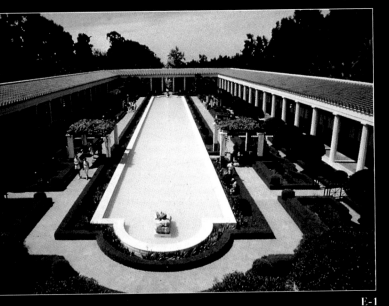

E-1

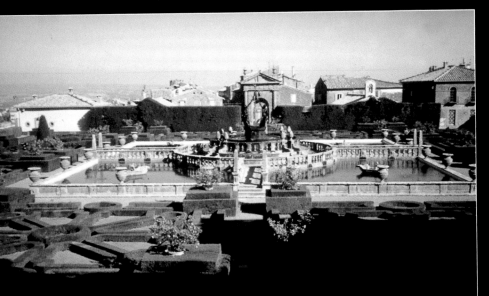

E-2

*T*he classical authors, especially Pliny the Younger, have transmitted to us descriptions of the grand parks that surrounded the noble residences of the period. In particular, they describe the wide diffusion of topiary art, in which certain evergreen species were shaped to form large grottoes, parterre, and even animals (fig. E-1). When classicism was rediscovered during the Renaissance, these motifs were reintroduced in gardens. Thus was born the "Italian garden" (fig. E-2).

In fact, examples of the gardens described by Pliny have not been found at Pompeii. Topiary art was well suited to large spaces and above all was a luxury permitted only to the wealthiest people. In contrast, the small Pompeian gardens were used to satisfy family needs and, even if they were pleasure gardens, they always contributed to the pharmacy of the house or the opportunity to eat a bit of fruit or fresh vegetables.

E-1. Reconstruction of the Villa dei Papiri.
J. Paul Getty Museum, Malibu.

E-2. Garden of the Villa Lante.
Caprara.

The rediscovery of Pompeii and Herculaneum had a different influence on the history of contemporary gardens. This occurred in the second half of the eighteenth century, when the "landscape garden" was becoming popular in Europe. This garden type sought to reintroduce the natural landscape, punctuating it, however, with striking angles: the chinoiserie, the medieval castle, the corner of a ruin. At Caserta, the earliest Italian example of this layout, the corner of the ruin was constructed with finds from Pompeii (figs. E-3–4).

In contrast, those who in the same period visited the excavations appreciated above all their romanticism, stirred by the vision of the ruins framed by vegetation, as an allegory of the contrast between life and death (fig. E-5).

E-3

E-4

E-3. English garden.
Caserta.

E-4. English garden.
Caserta. Corner with ruin. The columns were taken from the excavations of Pompeii.

E-5. Corner of Pompeii.

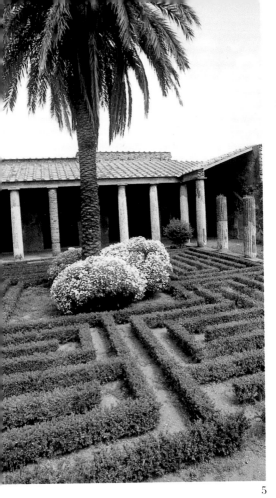

It was precisely stratigraphic excavation that posed the problem of the reconstruction of gardens and prompted the identification of the species depicted in the frescoes so that they could then be reintroduced into the flower beds (fig. 5).

Irrigation was provided by rainwater collected from the roofs and conserved in underground cisterns, usually in proportion to cultivation needs. This made it necessary to set the *viridarium* at the center of the house. With the availability of running water furnished by the aqueduct, some *viridaria* could be decorated with fountains and water plays.

Only recently has new laboratory research made it possible to correctly reconstruct a planting system. For example, in the case of the garden of the House of the Chaste Lovers, research has revealed how certain plant species were cultivated for decorative purposes in the flower beds; these plants were also useful in daily life, as medicinal plants and plants for wreaths.

The same techniques had been used in *Regiones* I and II, in which, as has already been said, the green areas that were utilized for disparate agricultural and artisan activities were concentrated. We are at the periphery of the city, far from the Forum, the center of social and economic life.

As in many modern cities, large sports complexes were located on the periphery. That is where Pompeii's Amphitheater and Great Palaestra arose. That is where greater availability of space allowed the possibility of having a more extensive residence, as Loreius Tibertinus and Julia Felix desired. That is where the owner of a green space could utilize it for activities other than cultivation. To again make a comparison with our cities, consider those meadows sometimes used as dumps for discarded cars.

The Amphitheater and Great Palaestra attracted many users. Large plane trees shaded the area. A famous fresco conserved in Naples, at the Museo Archeologico Nazionale, depicts those outside the colonnade of the Palaestra. The large casts still *in situ* provide further proof of the trees' presence (figs. 6–7). Their enormous dimensions indicate that the trees were very old, and make one think that they were positioned in the Great Palaestra because of their symbolic significance.

5. *Viridarium*
Pompeii, House of the Labyrinth. The solution adopted for the restoration of the gardens using the species illustrated in the frescoes was strengthened over time, so much so that in the 1950s the design of the labyrinth depicted in the house of the same name was recreated, utilizing boxwood hedges expressly shaped. The *ars topiaria*, namely the art of modeling plants, was "invented," according to Pliny, in 800 B.C. by Gaius Martius *(N.H.*, 12.6). Plants could also be "miniaturized," thereby obtaining those bonsai that are usually considered the prerogative of Oriental culture.

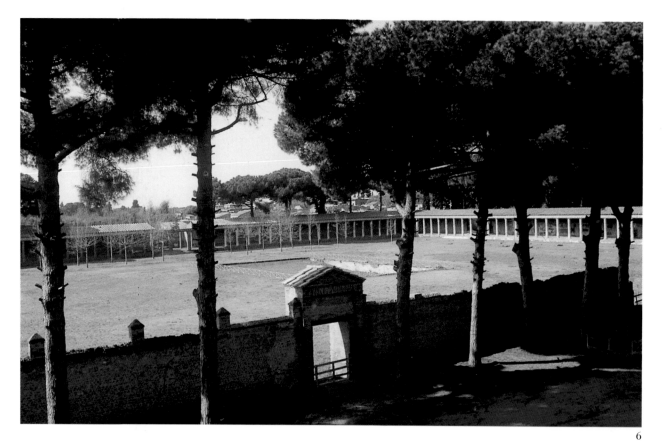

Plane trees also flanked the enclosure wall of the garden of Loreius Tiburtinus. This continuity, combined with the contemporaneity of the trees, could help archaeologists and urbanists to delineate the layout of the area prior to the construction of the respective buildings.

The garden of Loreius Tiburtinus, even more than the neighboring one of Julia Felix, represents the first and perhaps only example, among those excavated to date, that opens to the outside. The supply of running water provided by the aqueduct as well as the possibility of acquiring space made it possible to create a garden/park that was not enclosed within the house and therefore was of more ample dimensions.

A long pergola flanked both sides of a *euripus*, or watercourse, which was decorated with statues and fountains that spanned its entire length. Massive plane trees bordering the enclosure wall towered over midsize

6. Great Palaestra
Pompeii. It was decorated on three sides by a double row of large plane trees, whose casts are still *in situ*.

PERFUMES

*I*n the so-called Garden of Hercules, scented species such as roses (Campanian ones were highly requested precisely because they were particularly fragrant), lilies, and violets were cultivated. The olives in the same garden formed the oil base in which the essences were placed and macerated. To prepare the base, the olives were picked while immature, that is, still green, and then pressed.

The essences that were ground in oil could be used singly or in combination; sometimes they were added to spices imported from the East. Among those used, some could seem strange, such as basil and dill. It is just as true, however, that unguents used in curative massages were also included under the name of perfumes.

The importance of perfumes in daily life is commemorated in the pictorial cycle of cupids as perfume makers, a series of scenes in the House

F-1

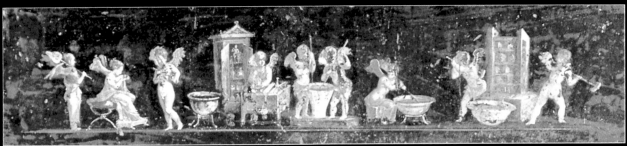

F-2

F-1. Cupids as perfume makers
Fresco (detail). Pompeii. House of the Vettii.

F-2. Cupids as perfume makers
Fresco. Pompeii. House of the Vettii.

F-3. Lily (*Lilium candidum* L.)
Fresco (detail). Pompeii. House of the Wedding of Alexander.

F-4. Pompeii. Garden of Hercules

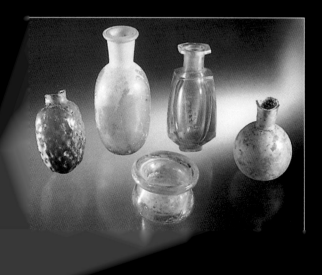

of the Vedu. In this cycle, the different phases of the preparation of perfumes, down to the testing of its smell by a charming matron, were emphasized.

The use of perfumes arose from the need to disguise underlying foul-smelling odors resulting from lack of personal hygiene, poor diffusion of sewage systems, use of solid organic waste in fertilizing fields, and liquid waste in bleaching fabric.

F-3

F-4

F-5. Stock (*Matthiola* sp.)
Fresco (detail). Pompeii. House
of the Wedding of Alexander.

F-6. Rose (*Rosa* sp.)
Fresco (detail). Pompeii. House of the
Wedding of Alexander.

F-7. Pompeii. storeroom
Glass containers for perfumes
and unguents.

F-5

44
—
45

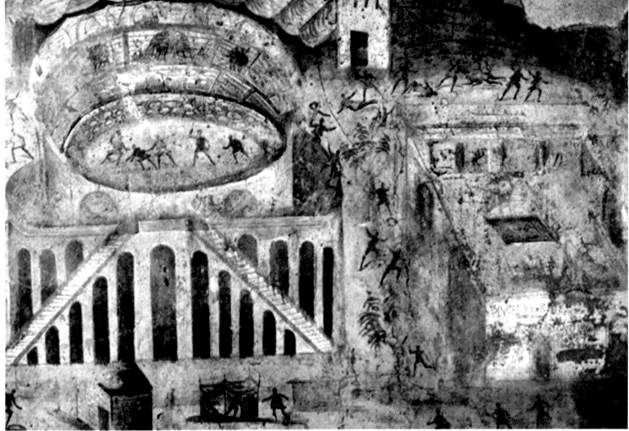

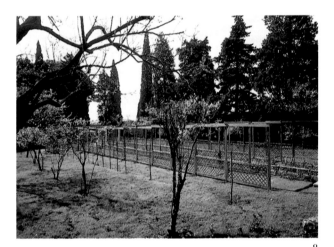

8

7. Battle between the Pompeians and the Nucerians

Fresco (detail). Naples, Museo Archeologico Nazionale. Casts of the roots of large plane trees are conserved in the Great Palaestra, which was shaded by double rows of the trees. To judge from their size, the trees must certainly have been centuries-old exemplars of the species *Platanus orientalis* L. Their nature is further demonstrated by the fresco of the battle between the Nucerians and Pompeians, today conserved in Naples. In the 1940s, archeologist and excavator Amedeo Maiuri, in redoing the lawn of the Great Palaestra, substituted for the double row of plane trees a single row of myrtles. Over time, the myrtles were partially destroyed and eventually overwhelmed by invading vegetation (bramble and wild fennel). In recent times, the grassy carpet has been restored by the attentive work of environmental recovery, which involved selectively intervening to control undesired species and to safeguard those that represent the current vegetal patrimony of the excavations. The double row of plane trees, chosen in a hybrid form, was reintroduced. From a naturalistic point of view, the enormous exemplars of *Pinus pinea* L. that tower over the Great Palaestra's exterior are noteworthy; in the 1940s, these were planted instead of the plane trees.

8. *Viridarium*

Pompeii, House of Loreius Tiburtinus. The garden of Loreius Tiburtinus was excavated at the beginning of the 1930s. Traces left on the ground reveal the presence of pergolas and arboreal cultivation. Casts of the roots of the latter were taken and examined by the director of the Botanical Garden of the time. These identified approximately the species, distinguishing ornamental ones (the plane trees) from those those that bore fruit, defined as trees of small and medium size or vines. On the basis of these indications, the garden's pergola was reconstructed and planted with vines. Cypresses were planted in place of plane trees. Maiuri justified this choice, on the one hand, as the most suitable to the romanticism of the sites and, on the other, by the necessity to avoid plants that would shed their leaves within the excavations, which would cause problems in the autumn. For the fruit-bearing trees, the choice fell on quinces for those of small size and on almonds for those of medium size. The garden was damaged during the Second World War and the wooden parts have only recently been reconstructed, whereas the trees, fortunately, are well preserved, offering a spectacular display in the spring.

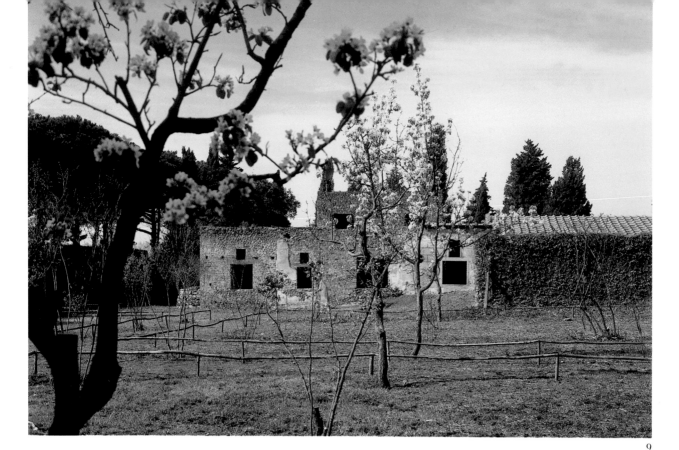

9

and large fruit trees, also set out in rows. At a higher level, another pergola shaded a transverse *euripus*, also decorated with statues and jets of water that poured water into the lower *euripus*. A small flower bed contained flowering plants that excavation data suggest were set out to trace the form of a heart (fig. 8).

The garden of Julia Felix also had abundant water and space. In contrast to that of Loreius, however, this garden was composed of two sections that each seems to have lived a life of its own. In one part, a great *viridarium* was adorned with statues and fountains. In the other part, a vast fruit orchard, divided by paths, was certainly used for strolling. However, it must also have served an economic function, insofar as it provided a ready supply of fruit for the frequent visitors to the house (fig. 9).

The ornamental use of fruit trees also occurred in the garden of Loreius Tiburtinus and elsewhere in Pompeii, especially in the small green areas of *Regio* I. Studies recently undertaken on the pollens, woods, and seeds, as well as the traces of cultivation found in this zone of the city, confirm this function. In particular, the discovery

46

47

9. *Viridarium* and fruit orchard
Pompeii, House of Julia Felix. The property of Julia Felix occupied an entire *insula*. It was divided into different quarters, including those of the patron, a bathroom for public use, shops, and rooms for rent. The dwelling was embellished with a spectacular garden spanned by a fishpond; other water features were in the west portico. Paths divided the ample vegetable garden. Cavities left in the ground by tree roots indicate the presence of a fruit orchard. The sale of garden produce probably entered into the commercial activity of the proprietor. In the 1950s, the garden was replanted. In this case as well, cypresses substituted for the grand plane trees that bordered the tall enclosure walls, whereas the choice of fruit-bearing trees fell on the different species represented in the frescoes: quinces, pomegranates, pear trees, apple trees, cherry trees.

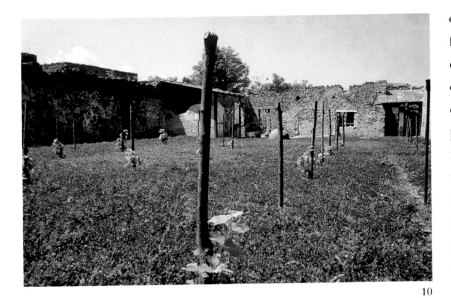

of a nursery that evidently furnished the city's urban gardens demonstrates that small trees were cultivated and used locally. For example, hazelnut trees were prized because they produced fruits suitable for long conservation; peach trees because the value of a single peach, a fruit that perished easily and was of recent importation, constituted in itself a small capital. To make a comparison, think of the price of a single kiwi fruit in Italy ten years ago, or of a fig in the United States.

In *Regio* I, therefore, excavations and laboratory research have made it possible to identify the presence of vegetable gardens, vineyards, and vast fruit orchards. The first were cultivated primarily for family use; excess produce was probably sold at market.

The cultivation of broad beans, peas, and lupins was alternated with that of cabbage, onions, garlic, and lettuce, to cite the most widespread vegetables. The great

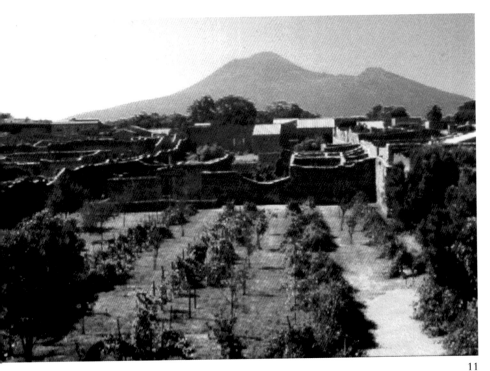

10

11

10. Vineyard
Pompeii. House of Euxinus.

11. Orchard
Pompeii. Garden of the Fugitives. The extensive area produced fruit above all. Its name reflects the fact that the casts of thirteen people, adults and children who attempted to escape the eruption of Vesuvius, were found here.

fertility of the soil made more than one harvest per year possible, and the vegetable garden must have generated revenue for the family.

Sometimes, the vegetable garden was associated with a vineyard and also included some fruit trees, rendering the household virtually autonomous with respect to the most common produce.

Single vineyards could attain vast dimensions, especially considering that they were within the city (fig. 10). The largest of all was one in the so-called Forum Boarium, or Cattle Market. Another huge vineyard stretched in the same zone on the other side of Via di Sarno. Not less extensive were the vineyards of Via di Nocera and Via di Castricio. All these vineyards were fitted out with equipment for winemaking, such as presses, underground pottery vessels called *dolia*, in which fermentation took place, and amphorae, for the conservation of wine. Some even had wine cellars.

12

The distance between the vines, both in and between rows, were given by Columella and Pliny in their works. The varieties cultivated must have been the *Colombina purpurea* and *Vitis oleagina*, progenitors of the modern local varieties *piedirosso* and *sciascinoso*, which are currently planted *in situ* according to the ancient order of planting. Sometimes, as in the case of the vineyard of Euxinus, a bar was set directly on the street, whereas in others, as in the Forum Boarium, vast *triclinia* accommodated the patrons.

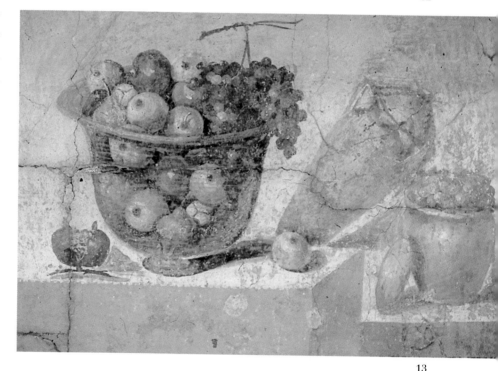

13

12. Fresco (detail)
Naples, Museo Archeologico Nazionale.

13. Fresco with representation of different fruits
Naples, Museo Archeologico Nazionale. Ancient frescoes make it possible not only to recognize different varieties of fruit but also to see the containers that held them: wooden baskets were used after harvesting, glassware for consumption at the table, and amphorae with covers for long-term conservation.

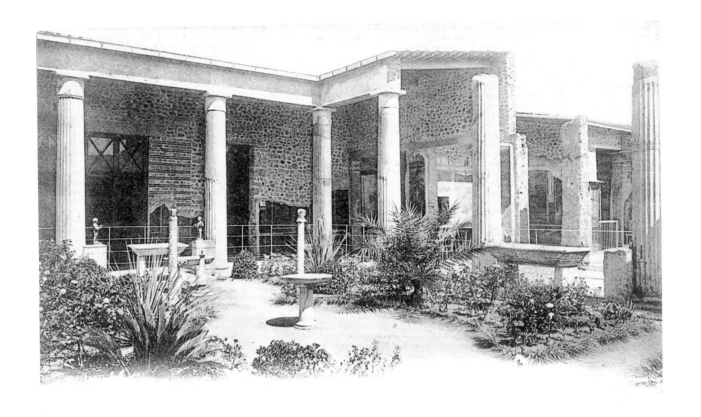

Such facilities for producing goods and selling directly to the public were not located in this area by chance. They were designed to intercept spectators going to and from the Amphitheater.

The extensive areas cultivated as fruit orchards were amply productive. In addition to the orchard annexed to the House of Julia Felix, already mentioned, other orchards were located at Garden of the Fugitives (fig. 11) and the garden of the House of the Ship Europa. In all cases, various species and varieties were cultivated. Some trees produced fruits that remained unaltered for a long time, such as nuts and hazelnuts; others bore pulp fruits, such as figs, pears, peaches, apricots, plums, and eating grapes, which were consumed fresh, conserved in honey, or sun-dried (figs. 12–13).

Figs were particularly important in the ancient diet because their high sugar content made them a ready source of metabolic energy. At the time, sugars derived from cane and beet-root were unknown.

But the extensive green spaces of *Regio* I were also destined for other uses. Products such as *garum* and matting

14. The *viridarium* of the House of the Vettii
Reconstruction from the beginning of the twentieth century.

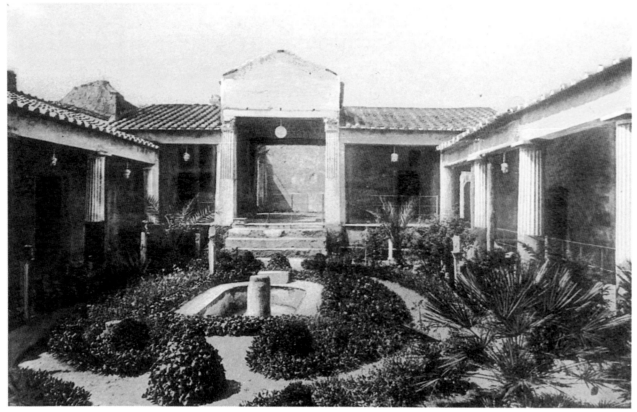

were stored in such places, and the space could be used for agricultural and artisan productions. For example, in the large vegetable garden of the House of the Perfume Maker, fragrant plants such as irises, roses, and violets were grown. These were then steeped in the oil produced from green olives harvested from the trees in the same garden.

Finally, the hypothesis has been advanced that plants for wreaths were cultivated in Pompeian gardens, especially those of more extensive dimensions. The current state of knowledge of this production, which must have been very widespread given the many uses for wreaths, is based only on iconographic clues.

Currently, Pompeian gardens in which it has been possible to identify the species actually cultivated in antiquity have been replanted according to their original use. Others have been left intact as evidence of outdated restoration efforts (figs. 14–15). In both cases, much attention is placed on preserving native species that have found refuge in those spaces.

15. Garden of the House of the Golden Cupids
Reconstruction from the Fascist period.

ESSENTIAL CULTIVATION: WHEAT, OLIVES, AND WINE GRAPES

The expansion of Mediterranean civilization is due, among other things, to three plants: wheat, olives, and wine grapes (figs. 1–4).

The cultivation of wheat is lost in the mists of time. When humankind realized that the seeds of a particular plant—one that had been roasted and ground between two rocks to make flour—could be planted in the ground to yield many ears of wheat with many more seeds, people set aside their nomadic activity to dedicate themselves to agriculture.

There are countless studies on the places of origin of wheat. Certainly, spontaneous forms of *Triticum* were present in the Mediterranean basin, but the path to the cultivated forms known to us is extremely long. It passed from forms of spontaneous hybridization to those consciously developed by man.

The most ancient forms of wheat were, for example, "in the husk." This term is used to indicate those cultivars of direct derivation from the spontaneous forms in which the caryopsis (the portion commonly called

1

2

1. Fields of wheat in Calabria

2. Oat (*Avena fatua* L.)
Strangely, according to Pliny, oat was not a species in itself, but rather a
degeneration of wheat caused by humidity.

the "grain of wheat") is separated
with difficulty from the glumes,
the bracts that covered them.

Ordinary threshing operations
were not sufficient to release the
seeds; therefore, the wheat was
first roasted. Some forms of wheat
in the husk were recognizable
among the carbonized finds
recovered at Pompeii, but
statistically these are few
compared with the others. This
demonstrates that the transition
between the two different forms
cultivated in the Vesuvian area in

3

the first century A.D. was concluding in favor of the
"nude" forms. The best-known example of wheat in the
husk is spelt; in order to thresh this wheat, the *pilum*
was invented. It consisted of a pair of pestles used in an
alternating and rhythmic manner.

The "nude" forms of wheat, which initially oc-
curred purely by chance, offered a distinct advantage
over wheat in the husk: the former's glumes were eas-
ily separated from the caryopses. As a result, the thresh-
ing operations, entrusted to the hooves of animals or
to flat stones drawn by them, were enormously simpli-
fied. The unusable parts of the plant were removed by

3. Olive grove on the slopes of Monte Alburno

4. Vineyard on the slopes of Monte Vulture
The importance of wheat, olives, and wine grapes for the population of the
Mediterranean basin has not diminished over the centuries. Even cultivation
techniques have remained unaltered for a very long time, having been mod-
ified only in the last few decades with the advent of mechanical means of
transport, especially in large agricultural establishments in the more devel-
oped countries.

4

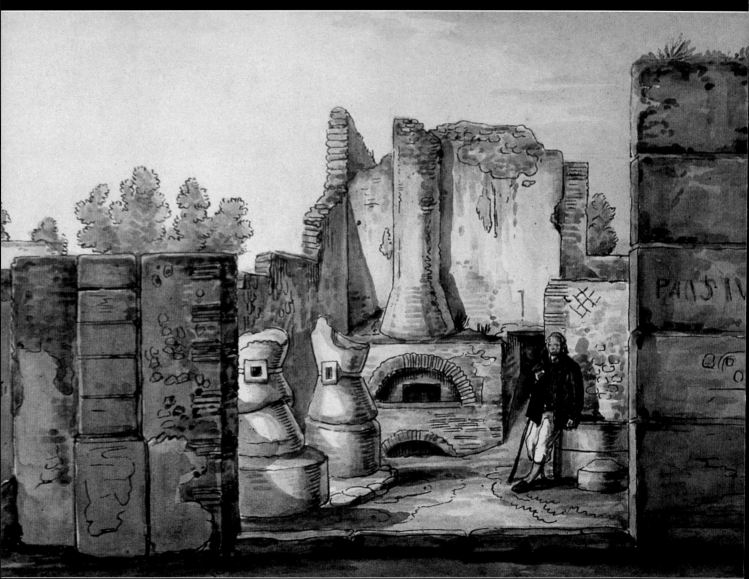

constructed of local volcanic stone; some were made of imported stone. They were probably intended for different types of flour. At any rate, in the friction between the stone and wheat, a slight continuous flaking of the stone occurred. Analyses carried out on fragments of carbonized bread reveals the presence of powdered stone in the flour.

The flour was then mixed with water and salt and, once kneaded, was given a rosette form and left to rise. Sometimes, the bakery owner's mark was impressed on the bread.

The best breads, like the desserts, were of white flour obtained from soft wheat. Breads of lesser quality, sometimes made from barley meal, were intended for the lower social classes.

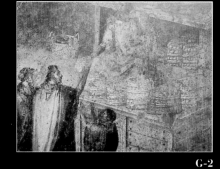

G-2

G-3

G-4

G-2. Pompeii
Painting that probably depicts the free distribution of bread by a baker (in a white toga) on the occasion of his election to a public office.

G-3. *Pilum* (reconstruction)

G-4. Millstone for grinding wheat

creating a breeze with a *ventilabra*, so that only the grains, which were then conserved in granaries, remained on the threshing floor.

The granaries were situated high up and with north-facing windows. To protect the wheat from attack by insects, olive dregs were mixed into the mortar used for building the granaries' floors and walls. This treatment protected the wheat from attack by insects and was practiced for centuries, at least until the late 1600s.

Another plant of prime importance in Roman life of two thousand years ago was the olive (fig. 5). Together with the wine grape, it was already considered a sacred plant in the Greek period. In the so-called tablets of Heraclea, for example, the lands of Metapontum were devoted to the cultivation of olives and grapes. The plants were sacred to Athena and Dionysos, respectively; damage done to these plants was punishable with death.

5. Olive trees (*Olea europaea* L.)
The olive tree is an extremely long-lived plant that can survive for up to
a thousand years. At present, the oldest specimens are in Greece.

Pliny (*N.H.*, 15.1) affirms that according to the historian Fenestella the olive was introduced to Rome in 581 B.C., during the reign of Tarquinius Priscus. The diffusion of its cultivation was such that the price of olive oil was ever decreasing, despite the fact that the tree grew extremely slowly.

Three different varieties of olives were known that did not require a great deal of care for cultivation, except for careful pruning. In the Vesuvian area, the olive's preference for calcareous soil resulted in its cultivation on the Lattari Mountains, as demonstrated by the frequent finds of oil presses at sites in that geographic region.

Then, as now, the best oil was derived by pressing freshly harvested olives that were still green or just colored. Oil presses and oil storerooms were oriented to face south, but were located far from heat sources, which could cause the oil to thicken and become rancid and bitter tasting.

Olives sweetened with brine were eaten whole or, according to ancient recipes, were crushed, flavored with herbs, and dried. At times, olives, together with bread and a bit of cheese, constituted the basic diet of the poorer social classes.

In addition to using the dregs of its fruit to protect grain, as described earlier, the olive tree had many other uses. The residue in the oil press was burned in lamps; the wood of the olive tree was used in cabinetmaking; the oil drawn from pressing immature olives became the base for unguents and perfumes.

In antiquity, the grapevine was placed between trees. When left free to grow, such vines reached very considerable dimensions. Pliny recounts that the Temple of Juno at Metapontum was supported by columns of the wood of the vine.

The progenitor of the cultivated vine, the wild grape, was native to the forests of the Caucasian region; perhaps cultivation began in Armenia. Since the grape is highly susceptible to mutation, probably little by little a plant bred larger grape clusters or sweeter grapes; eventually, a new cultivar was created using a scion. This explains the endless number of grape species; according to Pliny, only Democritos asserted that he could keep count of them all.

6–7. Different varieties of grapes
Frescoes. Naples, Museo Archeologico Nazionale.

OLIVE OIL

O lives for producing oil were harvested according to when they changed color. It was best to transport them immediately to the oil mill so as not to jeopardize the quality of the final product. Contrary to what happens nowadays, in antiquity a light pressing preceded the first pressing; it was executed, however, without crushing the pit.

A second pressing crushed all that remained, which was then collected in physcoli and pressed again.

In this way, the first operation yielded an oil of highest quality; the

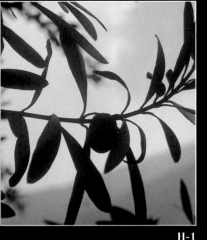

H-1

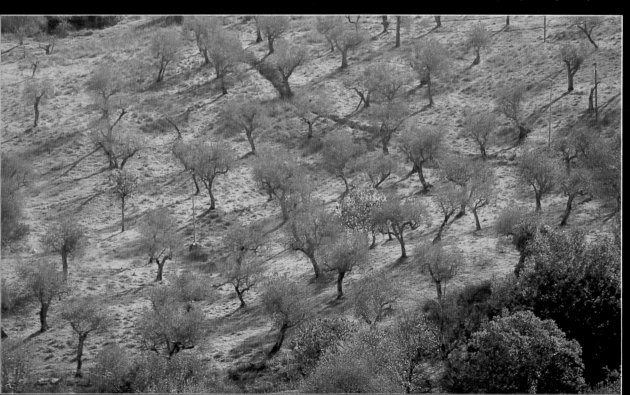

H-2

H-1. Olive branch (*Olea europaea* L.)

H-2. Olive grove
To obtain oil of better quality, the olives were harvested by hand from the tree. Harvesting from the ground and delayed harvesting resulted in lower-quality products.

second, an oil rich in dregs; the third, a product of lowest quality. The final waste was used as fuel for lamps.

It is interesting to note that the possibility of regulating the pressure exerted by the mill to achieve the type of pressing desired is described clearly by the classical authors (Pliny, N.H., 15.6; Columella, De agr., 12.52).

II-3

II-4

II-3. Reconstruction of an olive press
Rome, Museo della Civiltà Romana.

II-4. Old olive oil mill on the Amalfi coast.
The prototype of the millstone, whose use, according to Pliny, had been established shortly before his time, is conserved unaltered.

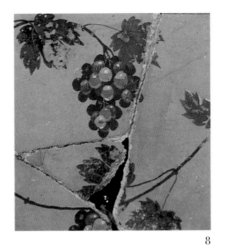

8

From Armenia, some species of grape reached the Caspian Sea and became widespread in Mesopotamia, Phoenicia, Egypt, and, later, Crete and Thrace. From there, grapes spread throughout all of Greece, arriving in Italy in about the sixth century B.C. and reaching the remainder of Europe toward 100 B.C.

Pliny lists an extremely large number of different types of grapes just for Campania, and many for the Vesuvian area alone. The literary citations find confirmation in the many visual representations of grapes, sometimes ones so precise as to permit the identification of the cultivar (figs. 6–9). In the study of the history of wine, in fact, information about the form of clusters and leaves, as well as the color and size of the grapes, permits comparison with current varieties in an attempt to delineate their direct ancestors.

In contrast with olives, grapevines required very attentive care. The Pompeians knew well that the ventilated and well-exposed Vesuvian slopes were particularly suited to growing grapes.

Growers took into account a vineyard's latitude and the quality of the vines planted out. In the plain, where it was more humid, elongated shoots were supported at great heights on poplars or elms in order to facilitate the maturation of the grape clusters.

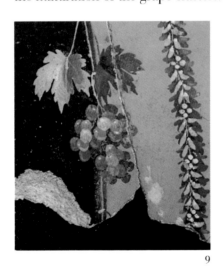

9

In the vineyards of the city, the cavities left by the roots indicate that plants were cultivated in rows according to a planting system whose distances and dimensions were recommended by the classical authors. Pergolas shaded the *triclinia* (just as long pergolas shaded the *euripus* of the garden of the House of Loreius Tiburtinus).

Even the varieties of eating grapes were cultivated on pergolas, usually systematized along the perimeter walls that enclosed vegetable gardens, vineyards, and fruit orchards.

On the slopes, grapevines were cultivated in rows and on frameworks. The latter are clearly visible in the representation of Bacchus and Vesuvius that adorned the *lararium* of the House of the Centenary.

8–9. Different varieties of grapes
Fresco fragments. Pompeii, House of Fabius Rufus.

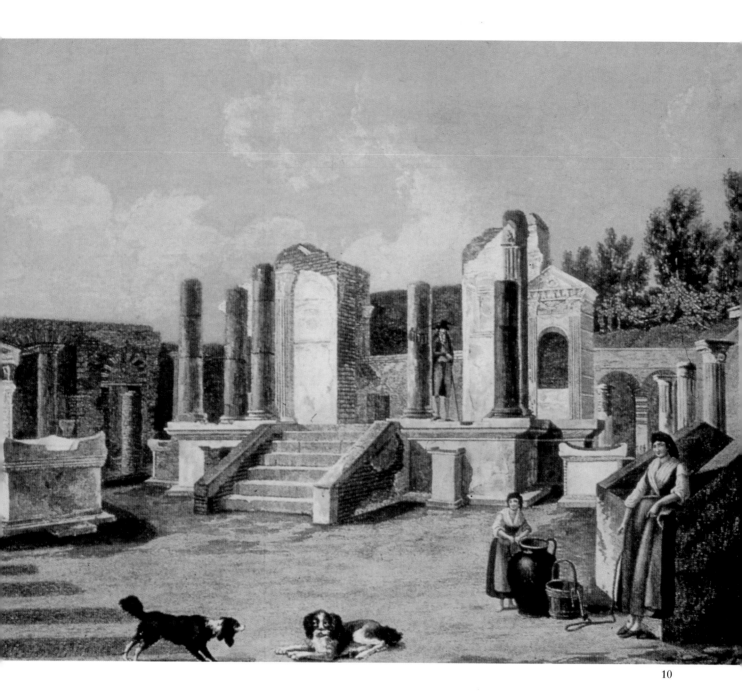

10

10. Pompeii, Temple of Isis
Gouache. Giacinto Gigante (1806–1876). Note on the
right the vines that use the poplars as a trellis.

GRAPES AND WINEMAKING

*T*he cultivation of grapes was widespread in the city and in the country. Like garum *production, winemaking was an important commercial activity of the Vesuvian area.*

The frequent finds of installations for the transformation of produce—wine cellars, dolia, presses, and amphorae, as well as carbonized wood and bunches of grapes—confirm the literary information transmitted by classical authors, who stressed the excellence of the local wines.

In the same way, iconography exalted the importance of viticulture. Commemorative representations, such as the many scenes of cupids gathering grapes (fig. 1-1) or the fresco discovered in the House of the Centenary: symbolic representations, in which the vine is set in relation to the Dionysiac rites (fig. 1-2): and the many representations of grape clusters themselves illustrated in different varieties all contribute information of great interest for the history of viticulture. Evidence from excavations demonstrates, in addition, how the very techniques of cultivation followed those that were the norms codified in Pliny and Columella regarding the vines' disposition and orientation. They were cultivated in rows (fig. 1-3) or "on frames" in drier sites or along hills. The

1-1

1-2

1-1. Cupids gathering grapes
Fresco. Naples. Museo Archeologico Nazionale.

1-2. Dionysiac rites
Fresco. Naples. Museo Archeologico Nazionale.

technique of tying the vines to poplar and elm trees at lower sites to permit the grape clusters to mature more easily far from the stagnant humidity of the ground was still in use in the Vesuvian region at the time of the earliest excavations; it now survives only in certain zones of the province of Caserta. The harvesting of grapes was followed by the processes for winemaking, which included the treading and first pressing of the

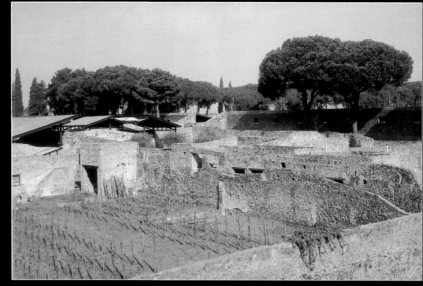

1-3

grapes (fig. 1-4), which produced the best wine, as well as further pressings, from which wines of lesser quality were obtained. The must was then fermented in dolia set into the ground. At the conclusion of the fermentation, the wine was decanted into amphorae and conserved in a wine cellar.

The great importance of viticulture and wine production was not due solely to the popularity of wine that was consumed for pleasure. It was an extremely important basic constituent of the so-called medicated wines, which had been steeped with plant essences containing active ingredients. Medicated wines were kept in the home pharmacy as medicines to treat short-lived ailments, such as stomachache, cough, or insomnia. This practice demonstrates how one could arrive in an intuitive manner at knowledge of the extractive capacity of alcohol, even though its nature obviously remained unknown.

1-4

62

63

1-3. Vineyard
Pompeii, Via di Nocera.

1-4. Press
Pompeii, Villa of the Mysteries.
The oldest model of the winepress used the weight of the beam for treading and the pressure exerted by the winch for pressing. With the invention of the continual winepress, the two operations were unified.

APPENDIX

PLANT LISTS

Species present in A.D. 79 in the Vesuvian area
This list, drafted on the basis of the identification of pollens, woods, seeds, and fruit found in the plain of the countryside and drawn from accounts by various contemporary ancient authors, includes all that has been published to date. **Names of species depicted in Pompeian frescoes appear in bold.**

Family	Species	Family	Species
Hypolepidaceae	*Pteridium aquilinum* (L.) Kunn		*R. gallica* L. var. *centifolia*
Polypodiaceae	*Polypodium australe* Fée		*R. gallica* L. var. *versicolor*
Pinaceae	*Abies alba* Mille		***Prunus persica* (L.) Batsch**
	***Pinus pinea* L.**		***P. dulcis* (Miller) D. A. Webb**
Cupressaceae	***Cupressus sempervirens* L.**		***P. dulcis* (Miller) D. A. Webb var.**
	Juniperus sp.		***pizzolantonio***
Salicaceae	*Salix* sp.		***P. cerasus* L.**
	Populus sp.		***Malus domestica* Borkh.**
Juglandaceae	***Juglans regia* L.**		***M. domestica* Borkh. var. *alappia***
	J. regia* var. *Sorrento		***M. domestica* Borkh. var. *annurca***
Corylaceae	***Corylus avellana* L.**		***M. domestica* Borkh. var. *clavilla***
	C. avellana* L. var. *lunga di Sarno		***Pyrus communis* L. var. *spadona***
Betulaceae	*Betula* sp.		***P. communis* L. var. *buoncristiano***
	Alnus glutinosa (L.) Gaertner		***P.s communis* L. var. *mastantuono***
Fagaceae	*Carpinus* sp.		***P. communis* L. var. *pennato***
	Ostrya sp.		***P. communis* L. var. *maddalena***
	Fagus sylvatica L.		***P. communis* L. var. *laura***
	Castanea sativa* Miller**		***P. communis* L. var. *moscarella
	Quercus pubescens* Willd.**		***P. communis* L. var. *zucchero
	Q. ilex L.		***P. communis* L. var. *Bergamotta***
	Q. cerris L.		*Potentilla reptans* L.
	Q. robur L.	Polygonaceae	*Polygonum persicaria* L.
Ulmaceae	*Ulmus minor* Miller		*P. aviculare* L.
Moraceae	***Ficus carica* L.**		*Fallopia convolvulus* (L.) Holub
	F. carica* L. var. *troiano	Chenopodiaceae	*Chenopodium vulvaria* L.
	F. carica* L. var. *lardaro		*Atriplex* sp.
	F. carica* L. var. *cucuzzaro	Portulacaceae	*Portulaca oleracea* L.
	F. carica* L. var. *molosso	Caryophyllaceae	*Polycarpon tetraphyllum* L.
	F. carica* L. var. *dottato		*Silene italica* L.
Rosaceae	***Rubus ulmifolius* Schott**		*S. nutans* L.
	R. fruticosus L.		*S. alba* (Miller) Krause
	***Rosa gallica* L.**		*S. gallica* L.

Family	Species	Family	Species
	Arenaria leptoclados (Rchb) Guss.		*T. cherleri* L.
	Petrorhagia velutina (Guss.) P. W.		*T. arvense* L.
	Ball and Heywood		*T. angustifolium* L.
Ranuncolaceae	*Ranunculus bulbosus* L.		*T. subterraneum* L.
	R. sardous Crantz		*T. pratense* L.
Guttiferae	*Hypericum* sp.		*Lotus angustissimus* L.
Lauraceae	***Laurus nobilis* L.**		*Ornithopus compressus* L.
Papaveraceae	***Papaver somniferum* L.**		*O. pinnatus* (Miller) Druce
	***P. rhoeas* L.**		*Pisum sativum* L.
	Chelidonium majus L.		*Cicer aretinum* L.
Cruciferae	*Brassica rapa* L.		*Lens culinaris* Medicus
	Sinapis sp.	**Geraniaceae**	*Geranium rotundifolium* L.
	Eruca sp.		*G. robertinianum* L.
	Lepidium sp.	**Linaceae**	*Linum usitatissimum* L.
	Raphanus sp.	**Euphorbiaceae**	*Euphorbia* sp.
Platanaceae	***Platanus orientalis* L.**	**Rutaceae**	***Citrus limon* (L.) Burm. F.**
Leguminosae	***Ceratonia siliqua* L.**	**Anacardiaceae**	*Pistacia* sp.
	Cytisus scoparius (L.) Link	**Aceraceae**	*Acer campestre* L.
	Lupinus angustifolius L.	**Vitaceae**	***Vitis vinifera* L.**
	Spartium junceum L.	**Malvaceae**	*Malva sylvestris* L.
	Vicia villosa Roth	**Guttiferae**	*Hypericum* perfoliatum
	V. lutea L.	**Violaceae**	*Viola tricolor* L.
	V. disperma DC.		*V. arvensis* Murray
	V. sativa L.	**Tamaricaceae**	*Tamarix gallica* L.
	Lathyrus sphaericus Retz.	**Cucurbitaceae**	*Cucumis* sp.
	L. clymenum L.		*Bryonia dioica* Jacq.
	L. aphaca L.	**Myrtaceae**	***Myrtus communis* L.**
	Trigonella corniculata (L.) L.	**Cornaceae**	*Cornus mas* L.
	Medicago orbicularis (L.) Bartal.	**Punicaceae**	***Punica granatum* L.**
	M. sativa L.		***P. granatum* L. var. *dente di***
	M. truncatula Gaertner		***cavallo***
	M. muricoleptis Tinco	**Arialaceae**	***Hedera helix* L. (var. *variegata*)**
	M. arabica (L.) Hudson	**Umbelliferae**	*Daucus carota* L.
	M. minima (L.) Bartal		*Apium graveolens* L.
	M. lupolina L.		*Torilis* sp.
	Trifolium campestre Schreber		*Aethusa* sp.
	T. glomeratum L.		*Tordilium* sp.
	T. lappaceum L.		*Ridolfia* sp.

Family	Species	Family	Species
	Caucalis plathycarpos L.	Liliaceae	*Eupatorium cannabinum* L.
Ericaceae	**Arbutus unedo** L.		*Allium sativum* L.
Primulaceae	**Anagallis arvensis** L.		*Allium coepa* L.
Oleaceae	**Olea europaea** L.		*Ruscus aculeatus* L.
	O. europaea L. var. **sorrento**	Gramineae	*Smilax aspera* L.
Apocynaceae	**Nerium oleander** L.		*Gastridium ventricosum* (Gouan)
Rubiaceae	*Galium aparine* L.		Sch. and Th.
Convolvulaceae	*Sherardia arvensis* L.		*Cynodon dactylon* (L.) Pers.
Boraginaceae	*Convolvulus arvensis* L.		*Anthoxanthum odoratum* L.
Verbenaceae	*Echium* sp.		*Agrostis stolonifera* L.
Labiatae	*Verbena officinalis* L.		*Lagorus ovatus*
	Sideritis romana L.		*Holcus lanatus* L.
	Calamintha nepeta (L.) Savi		*Arena barbata* Potter
	Marrubium vulgare L.		*Aira caryophyllea* L.
	Lamium sp.		*Cynorosus echinatus* L.
	Ocimum basilicum L.		*Poa annua* L.
Solanaceae	*Lycopus europaeus* L.		*Briza maxima* L.
	Solanum nigrum L.		*B. minor* L.
Scrophulariaceae	*Hyoscyamus albus* L.		*Lapochloa cristata* (L.) Hgl.
Plantaginaceae	*Veronica* sp.		*Vulpia myuros* (L.) Gmelin.
	Plantago lanceolata L.		*Bromus rigidus* Roth
Valerianaceae	*P. lagopus* L.		*B. madritensis* L.
Dipsacaceae	*Valerianella dentata* (L.) Pollich		**Hordeum vulgare** L.
Compositae	*Knautia arvensis* (L.) Coulter		*Lolium perenne* L.
	Filago germanica (L.) Hudson		*Triticum monococcum* L.
	Anthemis arvensis L.		*T. dicoccum* Schrank
	Chrysanthemum segetum L.		*T. turgidum* L.
	Calendula arvensis L.		**T. aestivum** L.
	Carduus pycnocephalus L.		**Arundo donax** L.
	Galactites tomentosa Moench		*Phragmites australis* (Cav.) Trin.
	Sonchus asper (L.) Hill	Lemnaceae	*Lemna* sp.
	S. oleraceus L.	Cyperaceae	*Carex flacca* Schreber
	Crepis neglecta L.		
	Hypochaeris glabra L.		
	Cirsium arvense (L.) Scop.		

Species currently present in the archaeological area of Pompeii

This list includes ornamental, edible, and commercially useful plants that have been identified in the parts of Pompeii already excavated, in the unexcavated area, and in the zone outside the walls. Species also present in A.D. 79 appear in bold.

Family	Species	Family	Species
Hypolepidaceae	*Pteridium aquilinum* (L.) Kunn		*Petrorhagia velutina* prolifera
Aspleniaceae	*Asplenium adiantum nigrum* L.		(L.) Ball and Heywood
Cupressaceae	*Cupressus sempervirens* L.	**Ranuncolaceae**	*Clematis vitalba* L.
Pinaceae	***Pinus pinea* L.**		*C. recta* L.
	P. halepensis Miller	**Guttiferae**	*Hypericum perforatum* L.
	P. pinaster Aiton	**Lauraceae**	***Laurus nobilis* L.**
Taxaceae	*Taxus baccata* L.	**Papaveraceae**	*Papaver hybridum* L.
Salicaceae	*Populus nigra* L.		*P. rhoeas* L.
	Populus tremula L.		*Glaucium flavum* Crantz
Corylaceae	***Corylus avellana* L.**		*Fumaria officinalis* L.
Fagaceae	*Fagus sylvatica* L.		*F. capreolata* L.
	***Quercus pubescens* Willd.**		*F. agraria* L.
	***Q. ilex* L.**		*F. bastardei* Breon Subett
Ulmaceae	***Ulmus minor* Miller**		*F. vaillantii* L.
Moraceae	***Ficus carica* L.**	**Cruciferae**	*Brassica rapa* L.
	Morus nigra L.		*Eruca* sp.
Urticaceae	*Urtica dioica* L.		*Raphanus raphanistrum* L.
	U. membranacea Poiret		*Aethionema saxatile* (L.) R. Br.
	Parietaria officinalis L.	**Resedaceae**	*Reseda alba* L.
Polygonaceae	*Rumex pulcher* L.		*R. luteola* L.
	Polygonum aviculare L.	**Platanaceae**	*Platanus hybridus*
Chenopodiaceae	*Atriplex* sp.	**Crassulaceae**	*Sedum sediforme* (Jacq.) Pam.
Portulacaceae	*Portulaca oleracea* L.	**Rosaceae**	***Rubus ulmifolius* Schott**
Caryophyllaceae	*Stellaria media* (L.)		Roses in different cultivars
	S. neglecta Weihe		*Rosa agrestis* Savi
	Silene nocturna L.		***Prunus persica* (L.) Batsch**
	S. nutans L.		***P. dulcis* (Miller) D. A. Webb**
	***S. alba* (Miller) Krause**		***P. cerasus* L.**
	S. noctiflora L.		***Malus domestica* Borkh.**
	S. dioica (L.) Clair		***Pyrus communis* L.**
	S. apetala Miller		*Potentilla reptans* L.
	S. dichotoma Ehrb.		***Cydonia oblonga* Miller**
	Cerastium holostoides Fnis ampl.		*Sorbus domestica* L.
	Hylander		*Crataegus monogyna* Jacq.

Family	Species	Family	Species
Leguminosae	*Ceratonia siliqua* **L.**	Violaceae	*Viola arvensis* **Murray**
	Cytisus scoparius (**L.**) **Link**	Tamaricaceae	*Tamarix gallica* L.
	Lupinus angustifolius L.	Cucurbitaceae	*Lagenaria sericera* (Molina) Standley
	Spartium junceum **L.**	Myrtaceae	*Myrtus communis* **L.**
	Vicia villosa **Roth**	Cornaceae	*Cornus sanguinea* L.
	V. cracca L.	Punicaceae	*Punica granatum* L.
	V. hybrida L.	Arialaceae	*Hedera helix* **L. (var. *variegata*)**
	V. onobrychioides L.	Umbelliferae	*Daucus carota* L.
	V. sativa L.		*D. gingidium* L.
	V. faba **L.**		*Foeniculum vulgare* L.
	Lathyrus pratensis L.	Ericaceae	*Arbutus unedo* **L.**
	L. annuum L.	Primulaceae	*Anagallis arvensis* **L.**
	L. aphaca **L.**		*A. foemina* **Miller**
	Trigonella corniculata (L.) **L.**	Oleaceae	*Olea europaea* **L.**
	Medicago orbicularis (L.) Bartal		*Ligustrum vulgare* L.
	M. truncatula **Gaertner**		*Phillyrea latifolia* L.
	M. lupolina **L.**	Apocynaceae	*Nerium oleander* **L.**
	T. hybridum L.	Rubiaceae	*Galium aparine* L.
	T. subterraneum **L.**		*G. odoratum* (L.) Scop.
	T. pratense **L.**		*G. album* Miller
	Lotus corniculatus **L.**		*G. parisiense* L.
	L. ornithophioides L.		Sherardia arvensis L.
	Gleditsia triacanthos L.	Convolvulaceae	Convolvulus arvensis L.
	Robinia pseudoacacia L.		*Calystegia sepium* (L.) R. Br.
	Pisum sativum **L.**		*Cuscuta europaea* L.
	Cicer aretinum **L.**	Boraginaceae	Echium vulgare L.
Geraniaceae	*Geranium rotundifolium* L.		*E. plantagineum* L
	G. robertinianum L.		*Borago officinalis* L.
Euphorbiaceae	*Euphorbia peplus* L.		*Cerinthe major* L.
	E. helioscopia L.		*Miosotis arvensis* Hill
	E. cyparisias L.		*Cynoglossum creticum* Miller
Rutaceace	*Citrus limon* (**L.**) **Burm. F.**		*Pulmonaria saccharata* Miller
	C. sinensis (L.) Osbeck	Labiatae	*Calamintha grandiflora* (L.) Moench
	C. aurantium L.		*Stachis officinalis* (L.) Trevisan
Anacardiaceae	*Pistacia lentiscus* L.		*Lamium album* L.
Simaroubaceae	*Ailanthus altissima* (Miller) Swingle		*L. purpureum* L.
Buxaceae	*Buxus sempervirens* **L.**		*L. amplexicaule* L.
Vitaceae	*Vitis vinifera* **L.**		*L. bifidum* L.
Malvaceae	*Malva sylvestris* **L.**		*Ajuga reptans* L.

Family	Species	Family	Species
	Glecoma hirsuta W. and K.		*Calendula arvensis* L.
	Thymus longicaulis Prel.		*Galactites tomentosa* Moench
	Mentha suaveolens L.		**Sonchus oleraceus L.**
	Rosmarinus officinalis L.		*Crepis biennis* L.
Solanaceae	*Solanum dulcamara* L.		*C. lacera* L.
	S. luteum Miller		*Cirsium vulgare* (Savi) Ten.
	S. nigrum L.		*Helychrysum italicum* (Roth.) Don
	Datura stramonium L.		*Galinsoga parviflora* Cav.
Scrophulariaceae	*Veronica arvensis* L.		*Senecio vulgaris* L.
	Verbascum sinuatum L.		*Centaurea deusta*
	Anthirrinum sicula Miller		*Taraxacum officinale* Weber
	Linaria purpurea (L.) Miller		*Cichorius intybus* L.
	Cymballaria muralis Gaertner		*Hieracium piloselloides* Vill.
Orobanchaceae	*Orobanche crenata* Forsskal		*Leucanthemum cratophylloides*
	O. ramosa L.	**Liliaceae**	*Allium sativum* L.
	O. rapum-genistae L.		*Allium coepa* L.
	O. minor Sm.		*Ruscus aculeatus* L.
Acanthaceae	*Acanthus mollis* L.		*Smilax aspera* L.
Plantaginaceae	**Plantago lanceolata L.**	**Gramineae**	*Lagorus ovatus*
Caprifoliaceae	*Sambucus nigra* L.		*Poa annua* L.
	Viburnum tinus L.		*Bromus erectus*
	Lonicera biflora Derf.		**Hordeum vulgare L.**
	L. xylosteum L.		*Lolium perenne* L.
Valerianaceae	*Centranthus ruber* (L.) DC.		*L. crenatum* Scrank
Dipsacaceae	*Dipsacus fullonum* L.		*Cynodon dactylon* L.
	Scabiosa maritima L.		*Setaria verticillata* (L.) Bauv.
Campanulaceae	*Legousia speculum-veneris* (L.) Chaix.		*Arundo donax* L.
Compositae	*Bellis perennis* L.		*A. Plinii* Turra.
	Anthemis arvensis L.	**Lemnaceae**	*Lemna* sp.
	A. segetalis L.	**Cyperaceae**	*Carex flacca* Schreber
	A. mixta L.		
	Chrysanthemum segetum L.		

BIBLIOGRAPHY

The bibliography relevant to the subject under discussion has been enriched in the last few years by a large number of books that recapitulate in turn all the preceding ones. It is therefore preferable to cite only the latest volumes, in order of their publication dates, and the relevant reference articles.

For in-depth studies on the landscape, see A. CIARALLO, "Il territorio del 79 d.C." (pp. 4–7), and, by the same author, "Evoluzione del paesaggio" (pp. 12–19), in A. CIARALLO and E. DE CAROLIS, *Lungo le mura di Pompei* (Milan, 1998).

For native and introduced species, see the articles of A. CIARALLO, "L'osservazione della natura" and "La flora" (pp. 37–42 and 46–47, respectively), in the exhibition catalogue *Homo Faber* (Milan, 1999).

For more complete information on cultivation and the landscape, on the use of plants in medicine or cosmetics, and on textile plants, see the articles of T. PESCATORE and M. R. SENATORE, "Le conoscenze geografiche" (pp. 43–45); L. CAPALDO, "La fauna" (pp. 48–50); L. CAPALDO and G. F. RUSSO, "Caccia e pesca" (pp. 83–84); M. BORGONGINO, "Le colture extra-urbane" (pp. 89–91); R. D'ORAZIO and E. MARTUSCELLI, "Il tessile a Pompei" (pp. 92–94); M. CIPOLLARO and G. DI BERNARDO, "La cosmesi" (pp. 111–14); and A. CASCINO, M. CIPOLLARO, and G. DI BERNARDO, "Medicina e chirurgia" (pp. 226–28), in the exhibition catalogue *Homo Faber* (Milan, 1999).

For Pompeian gardens, see W. F. JASHEMSKI, *The Gardens of Pompeii* (New Rochelle, N.Y., 1975), vol. 2, 1993; A. CIARALLO, *Orti e giardini di Pompei* (Naples, 1992); and M. MARIOTTI LIPPI, *Il verde urbano nell'antica Pompei* (pp. 87–88), in the exhibition catalogue *Homo Faber*, cited above.

Finally, the articles of E. De Carolis in both volumes are recommended.

The classical texts for reference are PLINY, *Natural History*, and COLUMELLA, *De re rustica*.